LITTLE BOOK OF
CELINE

Text © Frances Solá-Santiago 2025
Design and layout © Headline Publishing Group Limited 2025

Published in 2025 by Welbeck
An Imprint of HEADLINE PUBLISHING GROUP LIMITED

This book has not been authorised, licensed or endorsed by Celine, nor by anyone involved in the creation, production or distribution of their products.

1

Apart from any use permitted under UK copyright law, this publication may only be reproduced, stored, or transmitted, in any form, or by any means, with prior permission in writing of the publishers or, in the case of reprographic production, in accordance with the terms of licences issued by the Copyright Licensing Agency.

Cataloguing in Publication Data is available from the British Library

ISBN 9781035420582

Printed in China

Headline's policy is to use papers that are natural, renewable and recyclable products and made from wood grown in well-managed forests and other controlled sources. The logging and manufacturing processes are expected to conform to the environmental regulations of the country of origin.

HEADLINE PUBLISHING GROUP LIMITED
An Hachette UK Company
Carmelite House
50 Victoria Embankment
London EC4Y 0DZ

The authorised representative in the EEA is Hachette Ireland,
8 Castlecourt Centre, Dublin 15, D15 XTP3, Ireland (email: info@hbgi.ie)

www.headline.co.uk
www.hachette.co.uk

LITTLE BOOK OF

CELINE

The story of the iconic fashion house

FRANCES SOLÁ-SANTIAGO

WELBECK

CONTENTS

INTRODUCTION 6
THE ORIGINAL CELINE 18
THE TRIOMPHE 26
AMERICAN IN PARIS 40
WHAT NOW? 68
THE PHOEBE PHENOM 86
NEW CELINE 128
THE FUTURE OF CELINE 148
INDEX 156
CREDITS 160

INTRODUCTION

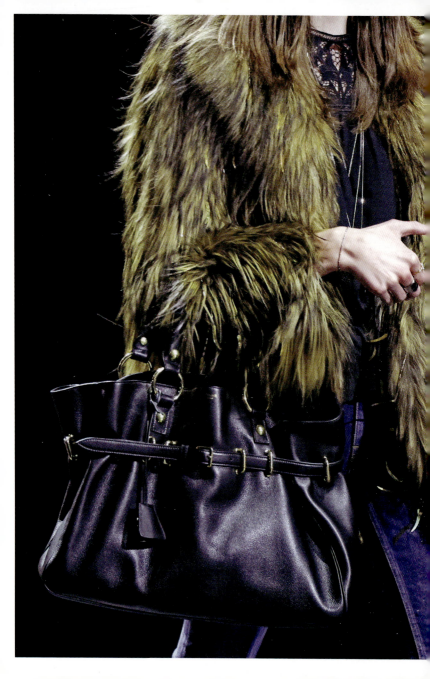

FROM PARIS TO THE WORLD

The Celine we know today is worlds apart from the brand Céline Vipiana launched in 1945. But throughout its many iterations and multiple creative directors, Celine has remained true to a singular vision: luxe sportswear with a Parisian sensibility. It's never too fussy or overdressed, but rather finds inspiration in the everyday lives of its customers, so that they may live comfortably in Celine's pieces.

A small shop grown into a global ready-to-wear and accessories empire, Celine's evolution is paved in contemporary elegance with a strong focus on serving modern women's needs. It's a mission that its past creative directors, from the Vipianas and Michael Kors to the Phoebe Philo phenomenon and Hedi Slimane's stewardship, have heralded throughout its history. And its iconic double-C logo, bridged with its nod to Paris's Arc de Triomphe, reminds its wearers of the brand's roots.

Cemented in the land of haute couture, Celine's long-standing emphasis on everyday fashion is a testament to why the brand captured a global audience. As former creative

OPPOSITE Celine's most recent era was shaped by Hedi Slimane's vision of youth culture.

director Michael Kors once said: "Celine has an amazing history of luxury and quality and a very French sort of indulgence." It's an example of the fact that, while many brands look to the avant-garde and the fantastic to make a statement, good clothes will always find a way to shine through the noise. After all, it's the everyday icons – the well-made double-breasted coat, the carry-all bag you can't stop wearing, the chic dress that goes from day to night – that truly make our wardrobes complete. Few brands can do that as well as Celine.

LEFT Throughout the decades, Celine's branding has been reshaped by its creative directors, as evidenced on this advertisement for the brand in France.

OPPOSITE Meghan, Duchess of Sussex, wearing Celine in 2022.

OVERLEAF Models showcase Celine's A/W 2008 collection at Paris Fashion Week.

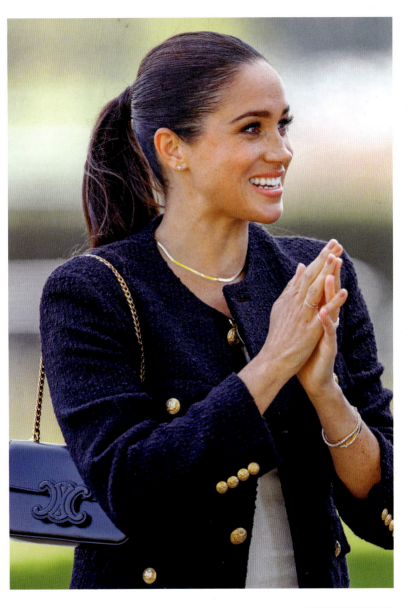

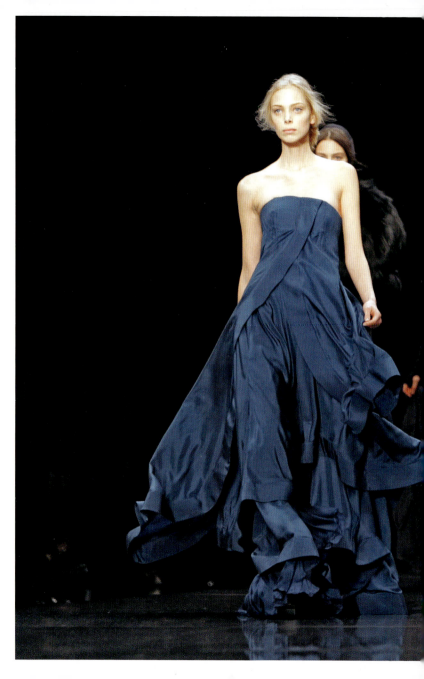

OPPOSITE Celine's handbag and accessories categories are some of the brand's biggest assets.

OVERLEAF Models wear Celine's S/S 2018 collection at Paris Fashion Week.

This book is a view into the creatives, items and symbols that made Celine the quintessential Parisian brand known globally today, with its focus on transforming everyday style into a major fashion moment. From its early days as a children's shoe shop to the global phenomenon of Phoebe Philo's tenure and Hedi Slimane's modern take on bourgeois fashion, Celine's 80-year history (with and without an accent) is filled with twists and turns that have infused the brand with modern DNA, making it one of fashion's most iconic labels.

By exploring Celine's history, it becomes clear why it continues to be such a force in the international fashion landscape. People today may associate Celine more with logo-heavy accessories and rock-edge clothing. But it's in the nook and crannies of its history – the complicated exit of one of its most revered creative directors, or the iconic campaigns that threw the internet into a frenzy, and the controversial aesthetic choices that transformed its most recent era that truly tell a complete story of the evolution of Celine.

Next time you walk by a Celine store, look closer. The story is all there.

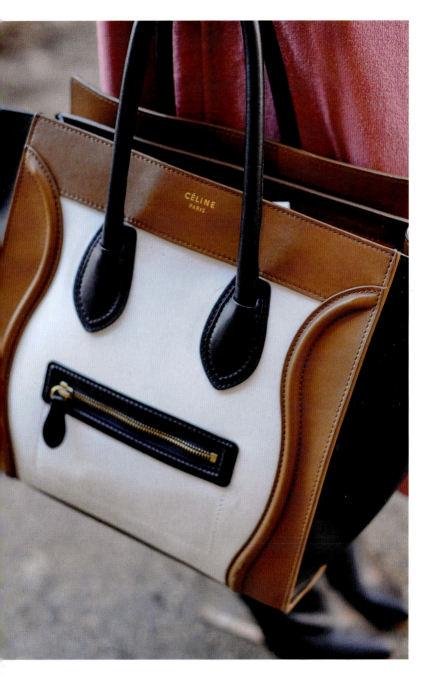

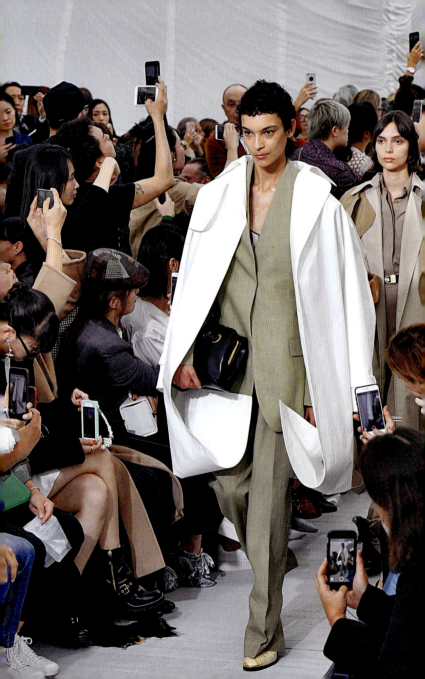

THE ORIGINAL CELINE

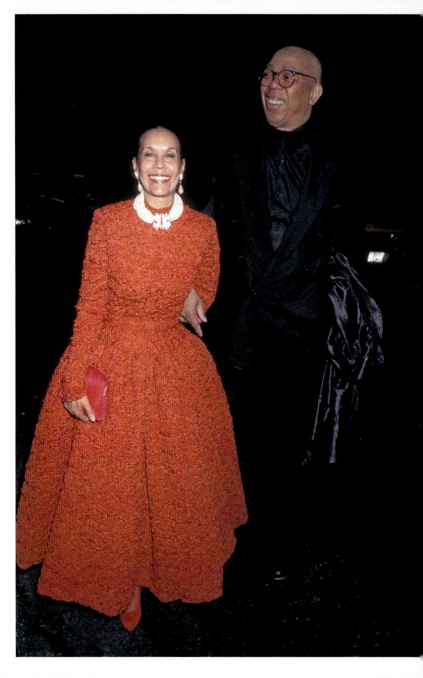

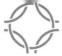

A LABEL DEFINES ITS HERITAGE

Today, Celine is synonymous with Parisian style, a certain blasé chicness that has captivated shoppers for 80 years. But its journey to becoming one of the world's most well-known fashion brands, celebrated for its iconic double-C logo and sophisticated leather goods, did not start with high fashion in mind.

First launched in 1945 by Céline and Richard Vipiana, Celine was a made-to-measure children's shoe shop. An initial boutique was opened on 52 Rue de Malte in Paris's 11th arrondissement. While today it's recognized by its double-C logo, back then, the Vipianas chose a more whimsical emblem: a red elephant designed by cartoonist Raymond Peynet, who was known in France for his illustration "Les Amoureux" that depicted two young lovers. By 1948, the brand had already expanded to three other stores in Paris.

But it would take nearly two more decades for Celine to transform from children's footwear to women's ready-to-wear, heavily focused on serving the bourgeois women of Paris.

OPPOSITE Celine quickly became a favourite of American socialites and sponsored benefits. Here, guests attend a Celine fundraising Gala in 1995.

OPPOSITE This classic Celine sporting look was showcased in 1975.

By the 1960s, the Vipianas had expanded the label to leather accessories, including bags, gloves and belts, as well as women's footwear, establishing a reputation for fine craftsmanship. The Vipianas also launched a Celine fragrance, called "Vent Fou". In 1967, the brand released its initial ready-to-wear line, described as "couture sportswear".

The collection was a hit and, over the next two decades, Celine developed a steady business for women's fashion and accessories, focusing on everyday wardrobe essentials and finely crafted accessories. The brand also transformed its logo from a red elephant to a simple typography emblem that also featured a horse and carriage over the word "Celine", embedding an equestrian feel to the label. Advertisements from the era show impeccably dressed women in items like white turtlenecks, plaid skirts and horse-bit belts. By the 1970s, the brand launched its most iconic logo – the Triomphe.

The 1980s were a pivotal decade for Celine. Its signature designs had reached beyond Paris, securing customers in other markets such as Japan and the United States.

The American capital proved to be a booming settlement for Celine. In the early 1980s, the Vipianas opened a boutique there to serve a "very affluent society and a city of widely traveled people and many foreigners and diplomats", as the boutique's then-owner Catherine Trevor told *The New York Times* back then. In November 1984, Céline Vipiana welcomed a group of Washington residents to the French Embassy to show her latest collection at a charity event in benefit of the Juvenile Diabetes Research Foundation International. Asked about why she opened the boutique in Washington, Vipiana said, "because all the big bosses are here". Vipiana appeared to have made some big connections in town, as she was later invited to a state dinner at the White House for His Royal Highness, the Grand Duke Jean of Luxembourg.

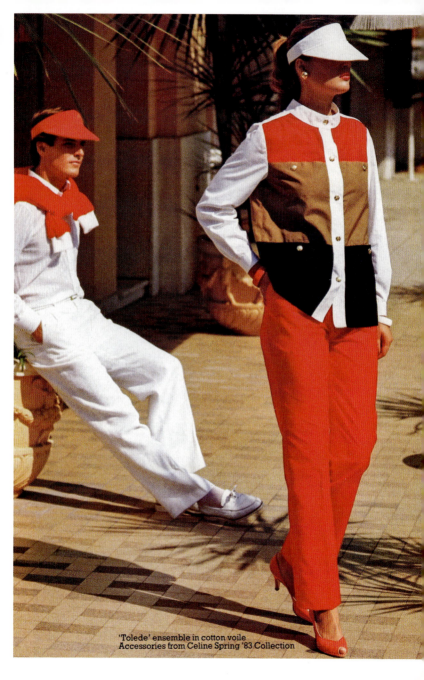
'Tolede' ensemble in cotton voile
Accessories from Celine Spring '83 Collection

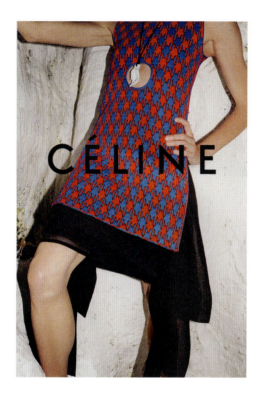

LEFT More recent creative directors were heavily influenced by the brand's early years, as evidenced by this 2015 ad campaign from Phoebe Philo's tenure.

OPPOSITE During the 1980s, Celine evolved its look to meet the times. Yet, it retained some of its signature elements, including gold buttons and sleek silhouettes.

Celine's success caught the attention of Bernard Arnault, the owner of French luxury conglomerate LVMH, and in 1987, he bought a stake in the company with the approval of the Vipiana family. By 1996, LVMH acquired the company in a deal valued at $540 million.

A year later, Céline Vipiana – the brand's matriarch and design visionary – died, leaving behind a 40-year legacy at Celine. With her small but mighty empire of boutiques and dedication to craftsmanship and everyday elegance, Vipiana cemented a fashion brand that is still thought of today as one of the only labels that knows how to dress women.

THE TRIOMPHE

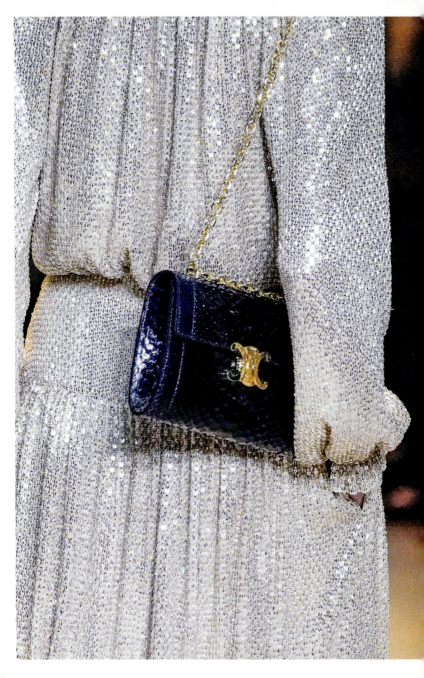

A LOGO FIT FOR A PARISIAN BRAND

"What could be more Parisian than the chain-link fence round the Arc de Triomphe?" – *Michael Kors*

It's the stuff of legend. Celine's iconic logo emerged from an unlikely place. It was 1972 and Céline Vipiana was driving in Paris when her car broke down right in front of the Arc de Triomphe, the arched monument standing at the western end of the Champs-Élysées. Stranded in the middle of Paris, Vipiana could do little else other than wander around the landmark, taking notice of the little details. It was there that she discovered the double Cs that became one of Celine's most remarkable emblems, the Triomphe.

Inspired by the iron chains around the monument, Vipiana settled on a chain-link motif with intricate double Cs facing in opposite directions. The logo debuted at Celine a year later. Since then, it's become the throughline between each creative director at the house of Celine. Some have highlighted it more than others, but look closely enough and references to the double Cs are found throughout the history of Celine.

OPPOSITE The Triomphe logo is one of Celine's biggest symbols.

Vipiana, for example, used it on everything from gold buttons and prints on clothing to details on footwear. A 1985 ensemble in the Metropolitan Museum of Art's collection shows a leather brown trench coat with a capelet detail and gold double-C buttons, while a 1982 gold clutch features the double-C logo protruding on top of its clasp. There were also more abstract references. A 1982 black rope belt features an embellished buckle with two moon-shaped figures facing one another as if recalling the Triomphe logo.

During his time at Celine, Michael Kors also pushed the Triomphe logo forward. "What could be more Parisian than the chain-link fence round the Arc de Triomphe?" he told Canada's *Fashion Magazine* in 2000. The designer got creative with the emblem, putting it on sandals, stitching it on jeans and turning it into buckles. A Celine 2000 ad campaign, for example, features Gisele Bündchen wearing a matching collared shirt and trousers set covered in a silver double-C logo print and carrying an equally printed backpack. Kors also featured the double-C logo on one of his most successful bags for the brand, the Boogie, doing monogram print versions, including in denim.

When Croatian designer Ivana Omazić took over the label in 2005, the Triomphe logo remained a steady mark for the brand. Her first collection featured top-handle bags and crossbody pouches with Triomphe hardware details. Yet as Omazić's collection progressed, the Triomphe logo was less visible on her accessories, signalling a more minimalist era for the label.

The double-C logo largely disappeared from the brand during the Phoebe Philo era, however. The designer's penchant for minimalism did away with heavy logos, preferring a simple typed "Céline" as its emblem. Instead

BELOW
The double-C monogram is one of the brand's defining symbols, exhibited in many items from clothing to handbags and other accessories.

of a double-C clasp on its bags, Philo's Celine opted for a rectangular clasp, seen on models like the Celine Trapeze and the Celine Classic Box.

As Hedi Slimane began transforming Celine, it was a flashback to the 1970s. Right from the start, the designer bet big on the double-C logo, making it a big selling point for his accessories at Celine. The Triomphe bag, a rectangular shoulder bag with a double-C logo on its clasp, was one of the brand's most successful accessories from when Slimane took over the brand in 2018.

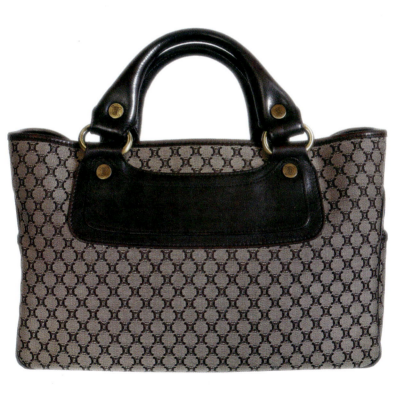

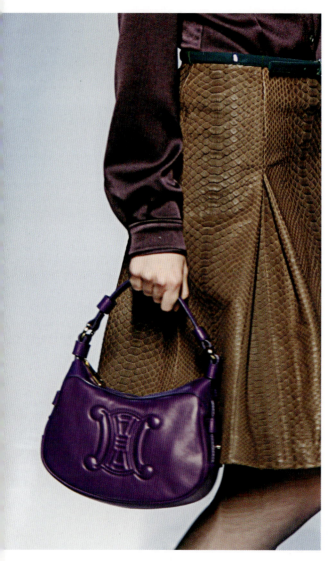

LEFT A model carries a Celine Triomphe logo handbag as part of the A/W 2005 collection.

OPPOSITE American actress Alexa Havins wearing a Celine handbag in 2004.

OVERLEAF Celine's Triomphe logo is seen across the brand's many categories, as well as its retail branding.

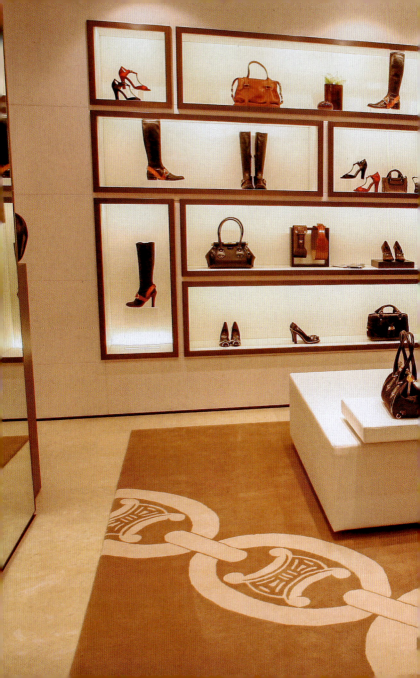

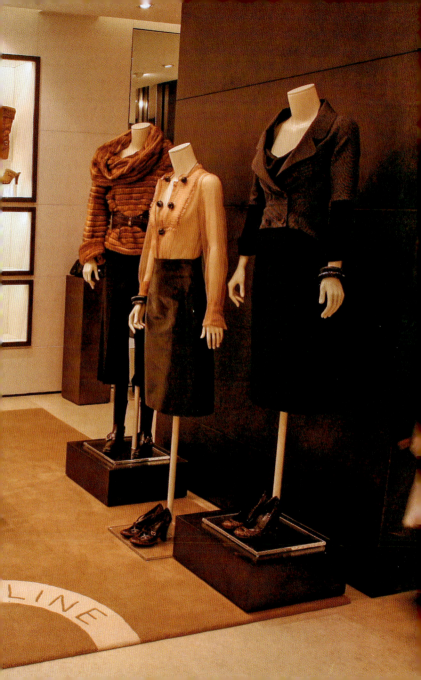

RIGHT A model carries a Celine Triomphe logo handbag for the S/S 2006 collection.

OPPOSITE
A handbag by Hedi Slimane, featuring the Celine Triomphe logo.

ABOVE Hedi Slimane has made Celine's Triomphe logo one of the biggest markers from his era leading the brand.

But it's far from the only accessory featuring the logo. There are T-shirts, sunglasses, hats, exercise equipment, headphones, hand fans and more that bear the Triomphe marker in modern Celine's lineup. It fast became one of Slimane's signatures at the label, where he managed to snag customers' love for logos, and the quintessential Parisian look of Celine's heritage symbol, to bring more shoppers to the brand.

If the Triomphe's origins are any indication, inspiration can truly come from the most unlikely of places, even being stranded in the middle of Paris.

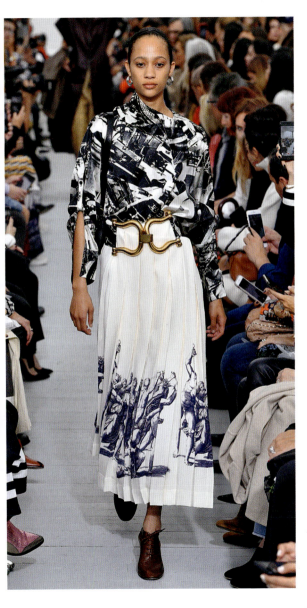

LEFT A model wears a belt resembling the Triomphe logo for the Celine S/S 2018 collection.

AMERICAN IN PARIS

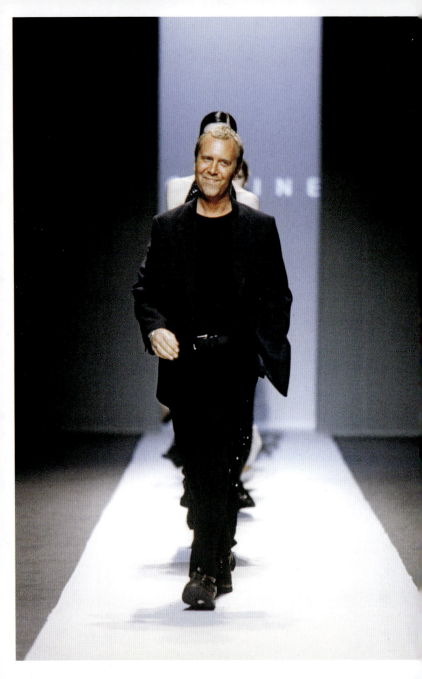

THE MICHAEL KORS ERA

For much of its history, Celine had remained an under-the-radar label led by its founders, expanding at a slower pace than the hyper-globalized and increasingly commercialized fashion industry of the 1990s. That was until LVMH came along.

By 1996, when the French conglomerate – owned by famed French businessman Bernard Arnault – acquired Celine, the brand had a strongly built heritage and customer base. But like many of its other labels, LVMH was seeking a dollar-turning expansion that could turn Celine into the next "It" brand of the millennials.

To do that, the company needed to hire a creative director who not only had the design savvy to build upon Celine's signature style but also the business acumen that could market it to a wider, global audience. The fashion landscape at the time was enthralled by young Americans coming to Paris. Marc Jacobs had just been hired by Louis Vuitton to establish the brand's ready-to-wear business, while Loewe had chosen Narciso Rodriguez to direct its vision. Celine decided on an emerging New York-based talent: Michael Kors.

OPPOSITE American designer Michael Kors was Celine's first-ever creative director after LVMH acquired a majority stake in the brand.

AMERICAN IN PARIS 43

A fashion school dropout, Kors had made a name for himself in the late 1970s when he worked at Lothar's, a New York City boutique where he started as a sales associate and became its head designer. There, he tended to clients like former First Lady Jacqueline Kennedy and actress Goldie Hawn. By 1981, Kors had been offered a space at Bergdorf Goodman – the iconic Manhattan department store – to sell his clothes. "I knew all of these women who shopped at Lothar's, and I told all of them, you know, 'I'm leaving, but I'm starting my own line'," Kors once told *GQ*. "So all of these women came, and we basically sold everything that was in the store." At the time Kors was just 22 years old, and soon had a booming business.

So when LVMH came knocking in the late 90s for the top job at Celine, Kors had already cemented himself as a designer-to-watch, thanks to his glamorous takes on sportswear and sharp tailoring. Among the American stars going to Paris, Kors was perhaps the one with the most understated stylistic vision, threading the line between extravagance and practicality with aplomb. "When Celine happened, it wasn't because we'd planned it. Or looked for it. But it just happened, like falling in love," Kors told *The Observer*.

His debut for Celine came when the designer showcased his Autumn/Winter 1998 collection, a display of luscious cashmere and effortless separates that mimicked the designer's line with a Parisian touch. "The indulgence and opulence of Paris is reflected in the clothes," he said then. The collection was met with critical praise, cementing Kors as another American making it big in Paris.

In taking the Celine job, Kors had been inducted into a new class of designers juggling all trades and ascending to unprecedented levels of mainstream fame. No longer a New York-based designer, Kors was jumping from the Big

OPPOSITE A model showcases the Celine A/W 1998 collection, Kors's first for the brand.

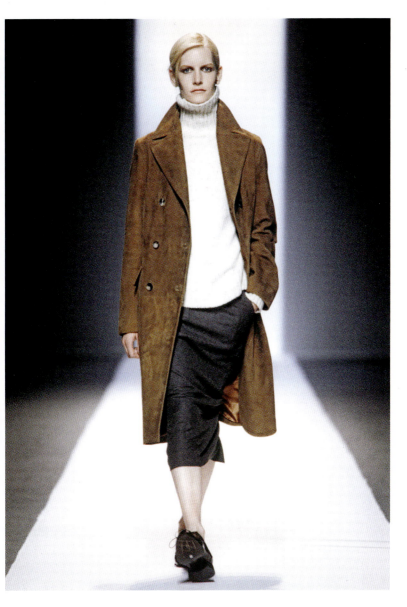

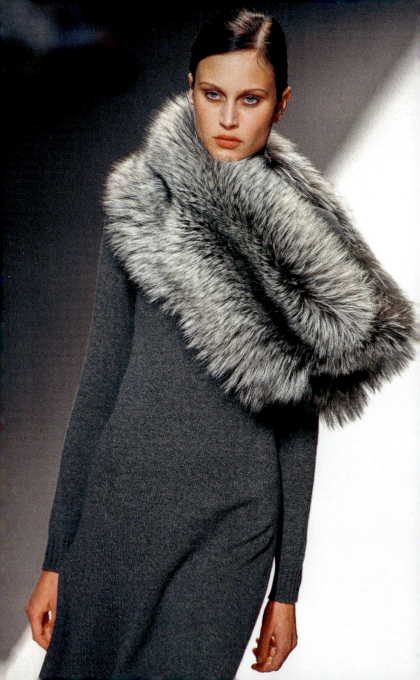

RIGHT Michael Kors's debut collection for A/W 1998 featured effortless separates and simple palettes.

OPPOSITE The Celine A/W 1998 collection mixed simple lines with Parisian opulence.

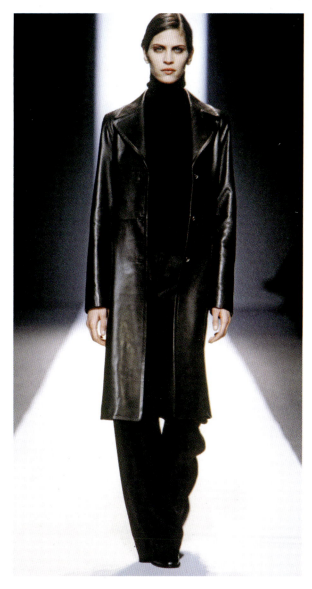

Apple to Paris for Celine and to Milan to meet with his line's manufacturers. "As if I wasn't consumed enough by fashion, look what happened next," he told *The Observer* at the time.

Yet Kors quickly proved he was up to the job and could bring more to Celine than chic separates and luxe sportswear. His early collections, which were Celine's first-ever dive into ready-to-wear, provided a footprint for what the brand's DNA would become decades after, a nuanced view of womanhood that fluctuated between glamour and utility. "The French like to play with their clothes; they have fun with fashion. This is really about mixing the two extremes – the very casual and the very luxe," he told Canada's *Fashion Magazine* in 2000.

Take, for example, his Spring/Summer 2000 collection, a lineup made to jetset that *Vogue* described as "Jennifer Lopez meets Jackie O in Saint-Tropez". It sure had the signature elements of a Kors collection: white button-down shirts and cropped jackets, for example. But its diva-like vivaciousness homed in on Kors's more dramatic side at Celine: a mostly blue and metallic palette, logo-printed tote bags and crystal-encrusted sarongs pushed the lineup into glamazon territory. He continued playing into this contrast with Autumn/Winter 2000, a celebration of the excess of the 1980s, which included fur-trimmed coats, leopard-print dresses, chain belts and tulle-hemmed dresses. Although seeking to revive the Madonna era, its main inspiration was Y2K "It" girl Chloë Sevigny, who at the time was nominated for an Oscar for her role in the film *Boys Don't Cry*. "I look at someone like Chloë Sevigny and she's got really amazing style – she wears very sophisticated clothes in an offhand way and that's the kind of girl we're talking about," Kors said in an interview with *Fashion Magazine* at the time. "It's the attitude that a woman brings to how she gets dressed." Writer Hamish Bowles saw it in a different light, writing of the collection: "Kors is obviously targeting the

glamorous young Park Avenue princesses who want to play dress-up in clothes they just remember their moms wearing."

After back-to-back themed collections, Kors dived right back into basics for Spring/Summer 2001. While the collection may have been inspired by desert landscapes, the result was a lineup with hints of escapism made for real life. A mostly neutral palette of khaki, green, black and brown was sprinkled throughout the collection, which included deep V-neck bodysuits and strapless tops, paired with low-rise bottoms and chic double-strap belts. The safari inspiration was seen through leopard-print swimsuits and cover-ups, as well as adventure-ready crossbody bags. By Autumn/Winter 2001, though, Kors's Celine took a detour. Inspired by the equestrian scenes of

BELOW
Designer Michael Kors and actress Chloë Sevigny, who served as a muse for one of the designer's collections at Celine.

AMERICAN IN PARIS 49

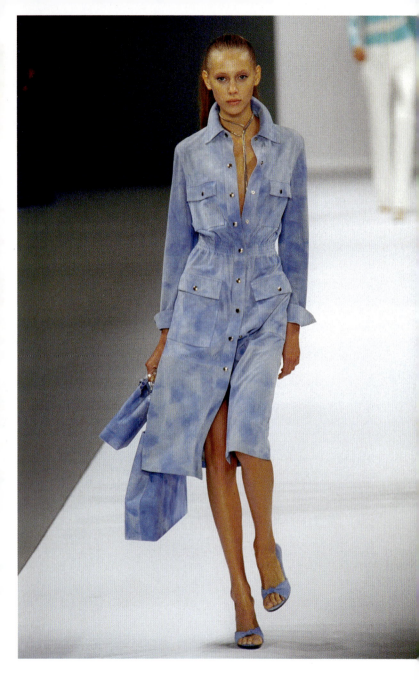

RIGHT Model
Gisele Bündchen
showcases the
Celine S/S
2000 collection.

OPPOSITE The
Celine S/S 2000
collection was
described as
"Jennifer Lopez
meets Jackie O
in Saint-Tropez".

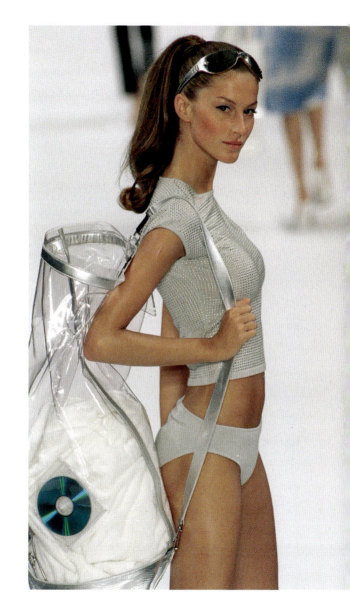

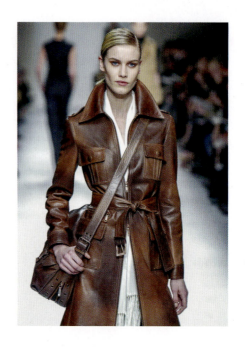

ABOVE The Celine A/W 2002 collection featured military-style jackets.

Nantucket and the S&M-ready fashion of Berlin, the collection showed the designer's knack for elevated sportswear was not a one-note tune. Though the lineup included more new-to-Kors pieces like military jackets, flowy puffer coats and plaid pieces, his signature elements were still shown: minimalist styling full of slip dresses, wide-leg trousers and oversized sweaters.

But Kors was not hired just for his take on chic sportswear. He had a task to expand the Celine business beyond ready-to-wear. In the late 90s, sales for leather goods – a long-standing category and the backbone of the brand's empire – had decreased to less than 7 per cent at Celine's stores in the United States. As the era of the "It" bag in the 2000s loomed, Kors looked to leather goods as a way to revive Celine's business, focusing on trendy bags.

RIGHT The Celine S/S 2001 collection was full of neutral palettes and simple lines.

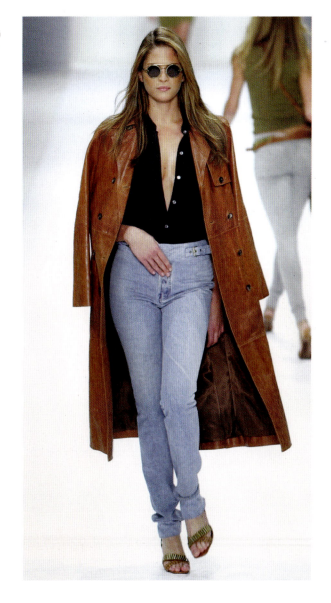

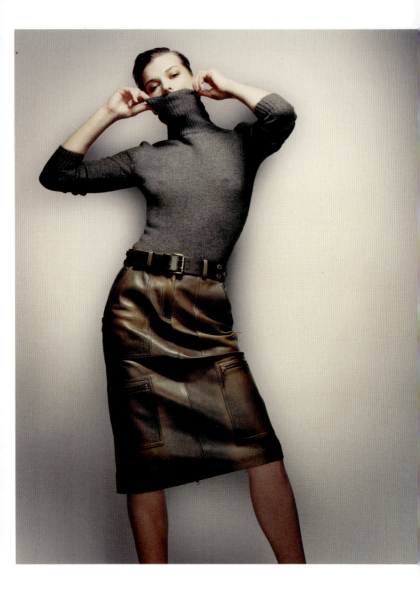

RIGHT Model and actress Karolína Kurková showcases the Celine S/S 2002 collection, which was full of practical summer staples.

OPPOSITE Actress Milla Jovovich in a Celine ad campaign for the A/W 2002 collection.

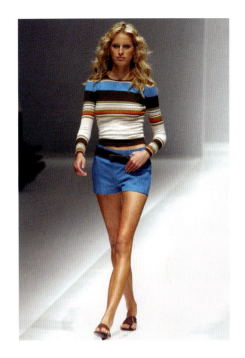

The first big hit came in 2002 with the Celine Boogie Bag. A carry-all tote bag with signature Parisian ease, the Boogie quickly earned celebrity fans like Madonna and Nicky Hilton, rivalling some of the "It" bags of the era, including the Louis Vuitton Pochette and Speedy bags. Like many Celine bags before and after it, the Boogie was inspired by Parisian heritage: contrasting stitching, multiple outside pockets and vast carry-on space that allowed its wearers to emulate the *je ne sais quoi* of the city's fashionable women, whose on-the-go style long served as inspiration for designers like Kors. By 2003, leather goods increased to 41 per cent of the brand's sales, according to *Women's Wear Daily*, while handbag sales had increased by 35 per cent.

OPPOSITE Models present the Celine A/W 2003 collection, which focused heavily on glamorous outerwear.

Kors followed it up with a few successful collections that signalled he had found his footing at Celine. He homed in on the military inspiration for Autumn/Winter 2002, flexing his outerwear muscles with fur-collared coats and aviator-style jackets. For Spring/Summer 2003, Kors took the Celine woman to India with a mix of 60s-inspired hippie style in a mostly pink-and-orange collection of easy minidresses, excessive jewellery and tie-dye prints. And by Autumn/Winter 2003, the mirage of pink-and-orange was replaced by a black-and-white palette that mixed in giraffe and zebra prints with hints of pale blue and pink, with Kors once again turning to outerwear as his hero category.

According to *Women's Wear Daily*, in 2003, Celine made a profit for the first time since 1996, the year Kors was hired. But just as Celine started to enjoy the spoils of Kors's work, the brand's relationship with the American designer began to wind down.

For all the success the designer brought to Celine, the separation was muddy. "Was I mistreated? No. Was I neglected? Yes," Kors said in an exclusive interview with *Women's Wear Daily* before his final show for Celine. He also revealed his work at the brand had been difficult from the start, acknowledging that it was hard for him to devote time to both his line and Celine. It was a flip from his early days at the brand when he told *The Observer:* "I switch between a baseball cap and a beret with great ease. Doing the two collections is good for me."

Although the designer's work at the brand had made Celine a Parisian ready-to-wear and accessories darling, Kors also revealed that he had not spent much time with LVMH's executives – more specifically, the company's CEO Bernard Arnault – a fact that made him realize Celine "was not going to become the priority". "So why am I going to keep trying to

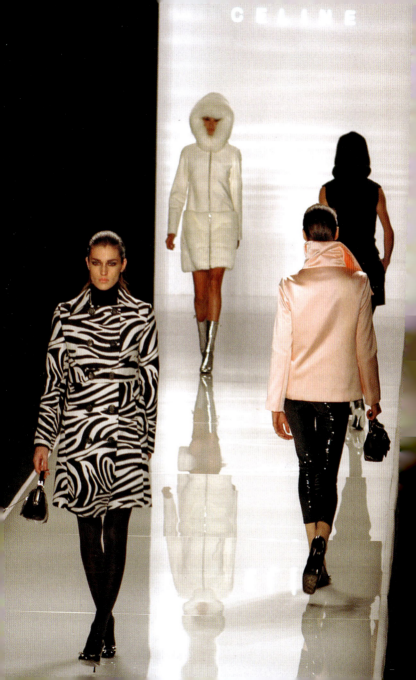

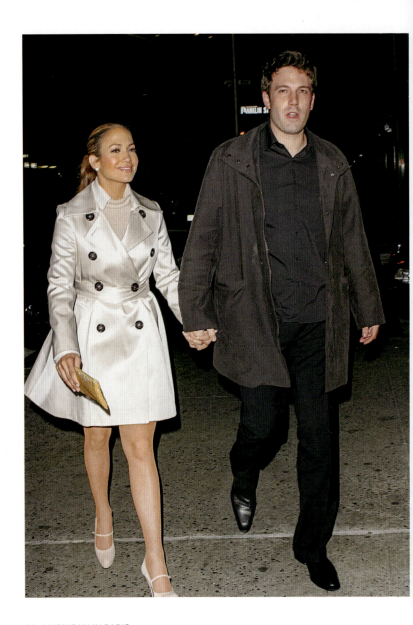

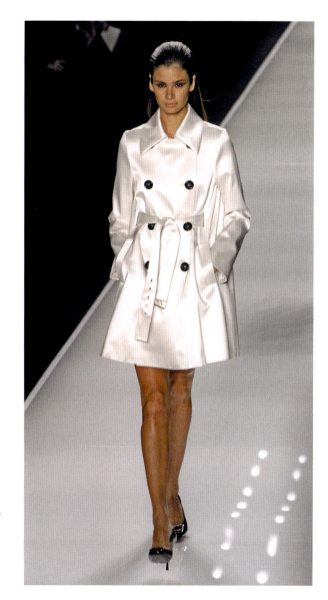

RIGHT A model presents the Celine A/W 2003 collection at Paris Fashion Week.

OPPOSITE Actress and singer Jennifer Lopez, alongside Ben Affleck, wearing the latest Celine coat in 2003.

ABOVE Designer Michael Kors posing backstage with models for the Celine show at Paris Fashion Week, March 2003.

OPPOSITE A model showcases the Celine S/S 2004 collection, which included hibiscus blooms and yucca-leaf prints.

make that happen?" he said. Kors, who alongside Marc Jacobs and Narciso Rodriguez had set a precedent for living and working in both the United States and France while helming luxury houses and their labels, emphasized in the interview that Celine needed someone "who could be the designer, full-time, who lived in Paris or is willing to move there, and that might not be someone who anyone has ever heard of".

Kors's second-to-last show gave no clues that things had been sour for the designer at Celine, though. It was joyful, full of colour, and unabashedly Kors. Inspired by the French Polynesian island of Tahiti, Kors seemed to want an escape, bringing the crystal blue waters and vibrant blooms of the Pacific to the Paris runways. "No one can deny this designer's gift for polish, nor his flair for optimism," *Vogue*'s Rebecca Lowthorpe wrote of the collection. It was in full display

RIGHT The S/S 2004 lineup featured chain prints that referenced the original idea for the Triomphe logo.

OPPOSITE Kors's second-to-last collection gave no indication that his time at Celine was coming to an end.

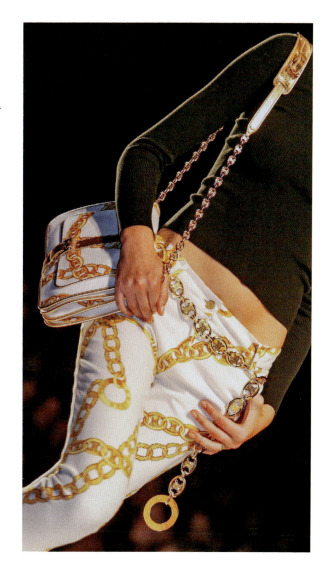

AMERICAN IN PARIS

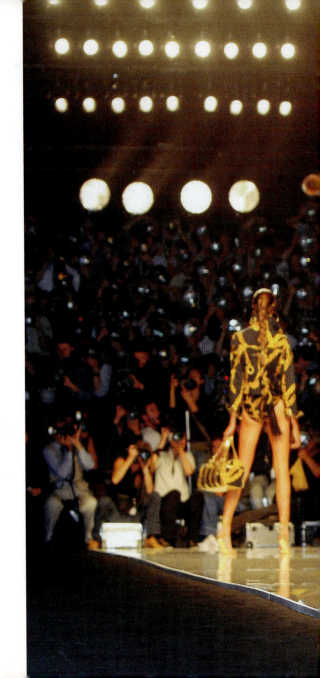

RIGHT A model walking the runway for Celine's S/S 2004 collection.

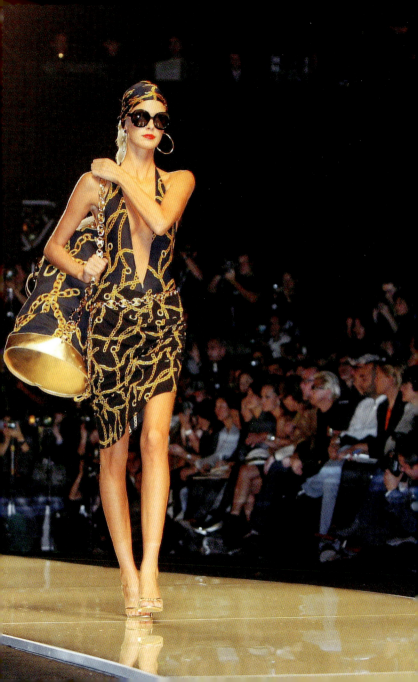

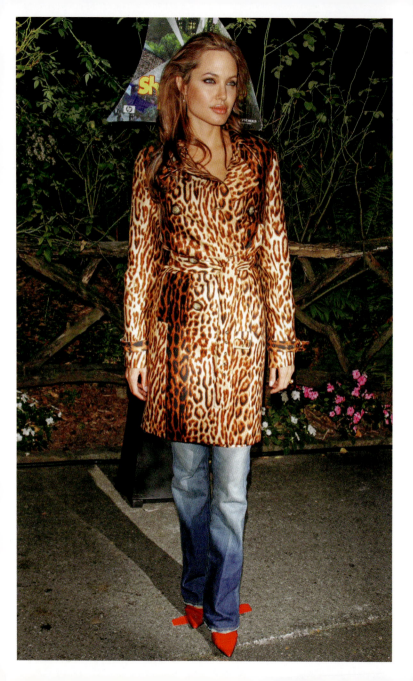

through hibiscus-printed shirts and skirts, relaxed sweaters paired with everything from bikini bottoms to miniskirts, and models wearing silk scarves on their heads. A mid-show lineup of black ensembles and accessories drenched in gold-chain prints paid tribute to Celine's heritage.

When it was time to show Autumn/Winter 2004, Kors took a second to reflect on what the brand had been before he took over. It was all about a ladylike sensibility, the bourgeois Paris woman that first inspired Celine. As he described in his show notes, the collection was inspired by the sportswear of women like C.Z. Guest and Carolyn Bessette-Kennedy, contrasted with the European poise of Leslie Caron, Jean Seberg and Audrey Hepburn. And so with that in mind, as Kors took his last bow, a sea of beige, black, grey, red and leopard adorned the runway by way of double-breasted skirt suits, chic column midi dresses with thin belts, and sexy flowy gowns in leopard prints.

For nearly a decade, Michael Kors made Celine a household name in fashion. When he bowed out, it was a mystery who would fill the role next. But it was clear that the brand's DNA as an industry mainstay was first seeded by Kors.

OPPOSITE Actress Angelina Jolie wearing Celine in 2004.

WHAT NOW?

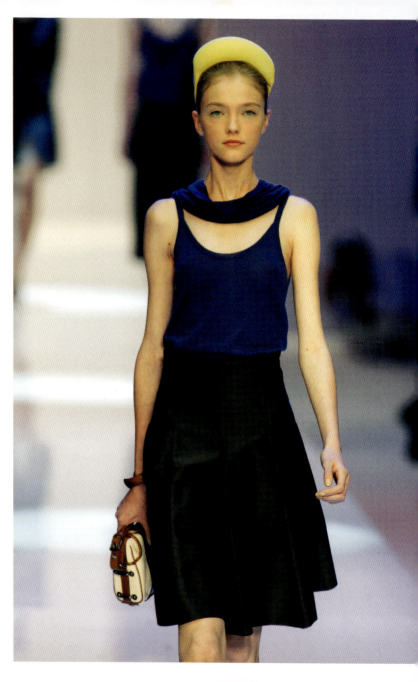

MENICHETTI AND OMAZIĆ TAKE THE LEAD

When Michael Kors decided to leave Celine to focus on his eponymous New York label, the future of the Parisian brand was somewhat uncertain. Kors had been the brand's first creative director since the death of its founder and LVMH's takeover, coming to define what Celine meant for shoppers. So, finding a replacement for Kors would be trying.

LVMH settled on Roberto Menichetti, a choice that was confirmed in the spring of 2004. A protégé of Jil Sander, Menichetti had been the creative director of Burberry for three years, reshaping the label and introducing its parallel line Prorsum, and later launching his own eponymous brand. Following Kors's departure, Menichetti took the reins of Celine, bringing with him a minimalist edge that was sure to take the brand in a new direction.

OPPOSITE A model presents the Celine S/S 2005 collection, Menichetti's first.

BELOW Roberto Menichetti with models backstage during Paris Fashion Week, October 2004.

OPPOSITE Menichetti's second collection was met with mixed reviews. *Vogue* called it "safe and predictable".

His debut was the Spring/Summer 2005 collection, a lineup that *Vogue*'s Mark Holgate described as a "wildly different aesthetic" to the one Kors presented during his tenure. Whereas Kors had a penchant for glamour, Menichetti was interested in a more practical perspective of luxury, which he presented by way of a blue, lime green and pink palette across sleek camisole tops, knee-length wide-leg capris, geometric-printed minidresses and bulging headbands on every single model.

The critical reception was far from welcoming. Critic Suzy Menkes wrote of the collection for *The New York Times*: "In spite of the Italian designer's efforts, from the huge colourful lanterns hanging above the runway through leafy prints and candy colours on ultrashort dresses, this was not a sunny start." *Vogue*'s Sarah Mower later referred to the collection as a "perplexing debut".

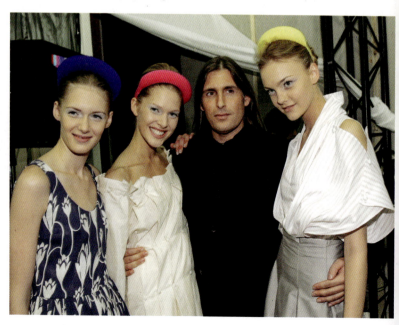

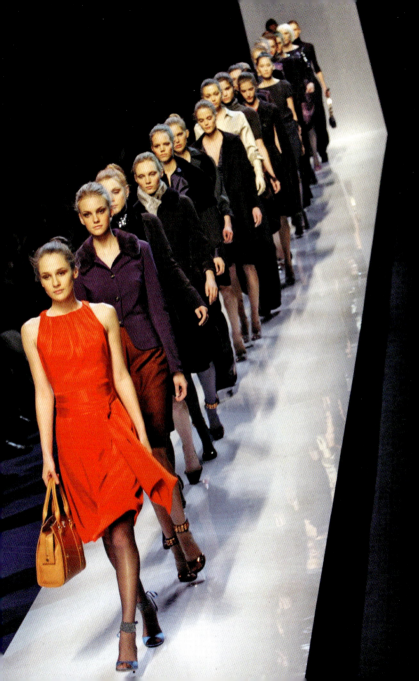

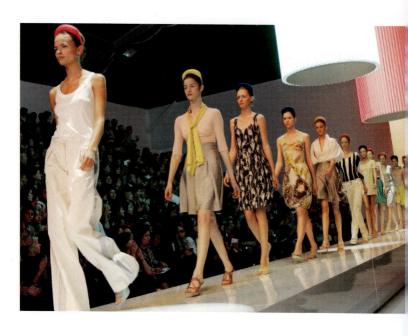

ABOVE The S/S 2005 collection featured a more minimalist vision for Celine that was not well received by the press.

For his Autumn/Winter 2005 collection, his second for the label, Menichetti tried to compromise his minimalist take with the brand's history of bourgeois dressing. In a play for conservative types, Menichetti put out fur-lined coats, cropped blazers, pencil skirts and flowy trousers juxtaposed with a contrasting palette of orange, blue, purple and pink. Though the attempt seemed genuine, *Vogue*'s Sarah Mower reviewed the collection as a failure to achieve "luxe simplicity" and described the lineup as "safe and predictable". When the runway show was over, Menichetti did not come out to take his bow, leaving the audience wondering what might come next for the brand.

It only took two months for LVMH to announce that Menichetti would leave Celine. According to *The New York Times*, a spokesperson for Menichetti said that the designer "wanted to spend more time working on his own collection".

Although Menichetti's Celine received a sour response, according to *The New York Times*, the disagreement between LVMH and the designer was motivated by how much time Menichetti could work on Celine in Paris as he kept his duties to his label in Italy. Menichetti's tenure at Celine was short and not so sweet.

By that autumn, Celine had a new designer: Ivana Omazić. The Croatian designer would be the first woman to take over the reins of Celine since its founder. An alum of Prada, where she spent seven years working under Miuccia Prada and Patrizio Bertelli, Omazić's lifelong dedication to fashion – she started saying she'd be a fashion designer as a little kid – was inspired by her mother and aunt. The latter was the London-based designer Franka Stael von Holstein, who dressed the likes of Ava Gardner.

BELOW Designer Ivana Omazić took the lead at Celine, following Menichetti's departure.

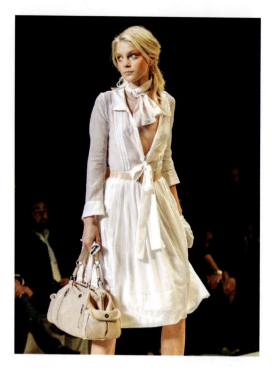

LEFT Model Jessica Stam presents the Celine S/S 2006 collection.

OPPOSITE Omazić's vision of Celine featured more feminine silhouettes with a strong focus on A-line skirts.

OVERLEAF Models showcase the Celine A/W 2006 collection, which relied heavily on a palette of grey and black.

When she was hired at Celine at 32, Omazić promised a new era for the brand. "It won't be Fifties, Sixties or Seventies. It will be 2006," she told *Women's Wear Daily*. "I'm part of the new generation and I want to experiment and to go forward." Omazić's debut came in the Spring/Summer 2006 collection, which opened with fiery orange minidresses and floppy hats, followed by white and beige trench coats, black cut-out swimsuits and flirty navy dresses. For *Vogue*'s Sarah Mower, it was an unsuccessful opening statement from Omazić. "Quite possibly taken apart and seen on a rail, this collection will look far more attractive," she wrote. "But styled and presented like this, it just didn't work."

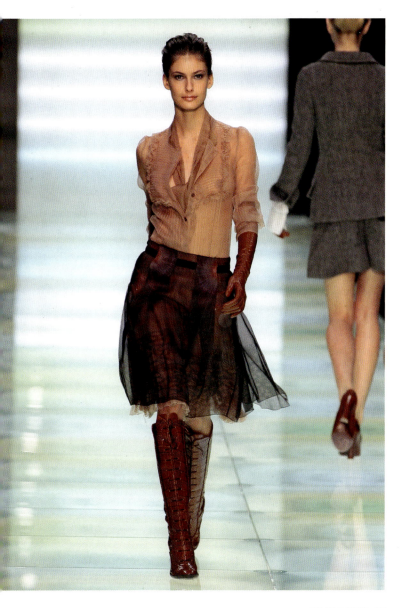

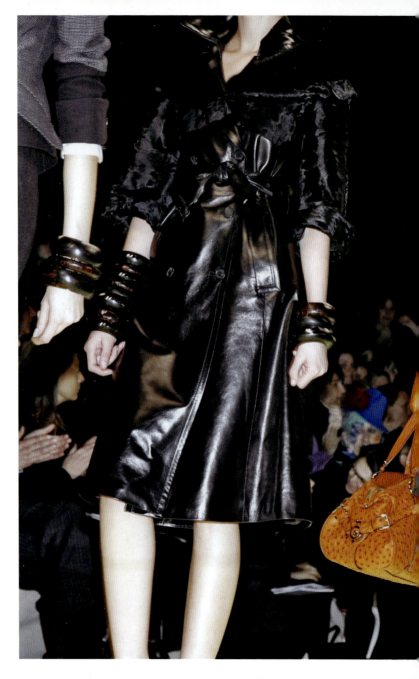

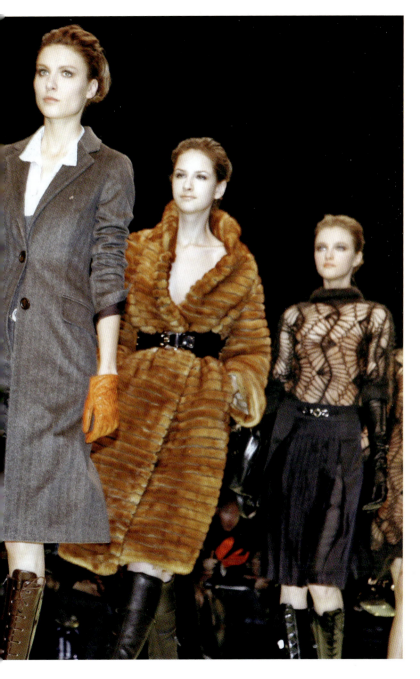

BELOW Designer Ivana Omazić with models backstage at Paris Fashion Week, October 2006.

It took some time for Omazić to find her footing at Celine. For the Autumn/Winter 2006 collection, Omazić relied on a heavy contrast of greys and pale pinks, moving between the structure of classic skirt suits and sheer flowy skirts. She once again bet big on black, pairing knit turtlenecks with sheer A-line skirts and knee-high leather boots. Omazić wore an iteration of this outfit when it was time to take her bow. Yet, the reviews did not show Omazić was winning over the industry. "What does Celine stand for?" asked *Vogue*'s Nicole Phelps in her review. "[Ivana's] grace period is up, without a clear indication she's capable of answering that tough question."

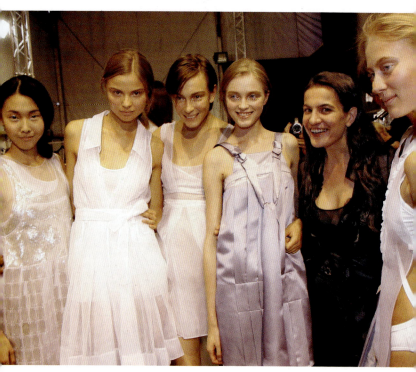

For Spring/Summer 2007, Omazić seemed to have turned on the lights, betting on a mostly white palette with black contrasts towards the end of the lineup. She cited the 1984 novel *The Unbearable Lightness of Being* as inspiration for the collection, marked by cinched waist suits, tuxedo-like vests, iridescent skirts and metallic trench coats. Though still received with sour reviews, the editorial response was more positive than her last two offerings. And with the Autumn/Winter 2007 collection the following March, a new door of possibilities for Omazić opened.

Inspired by the 1977 novel *The Unmade Bed* by Françoise Sagan, the collection homed in on Omazić's idea of French chicness. "I like a woman who's feminine, but not a doll," she said to reporters backstage. The lineup was full of classic Parisian pieces: belted sheaths, berets, cropped leather jackets, wrist gloves and pencil skirts in a mostly black-and-white palette with dashes of bright green, red, orange and yellow. For critics like *Vogue*'s Nicole Phelps, it was an "improvement" from past collections.

But Omazić truly found her footing at Celine a season later with the Spring/Summer 2008 lineup. All the elements of Omazić's Celine were there: ultra-feminine A-line dresses with flouncy knee-length skirts and a simple palette of black, white and red with sprinkles of turquoise and pink throughout the collection. But there was an ease in the styling that turned to simplicity, achieving more than past fussy collections had. Instead of overly accessorized looks (for Autumn/Winter 2007, for example, models wore heavily layered looks, gloves, hats and bags that seemed to clash with one another), this time, Omazić went basic with sleeker silhouettes and styling that lent itself to onlookers thinking to themselves, "Oh, I could wear that."

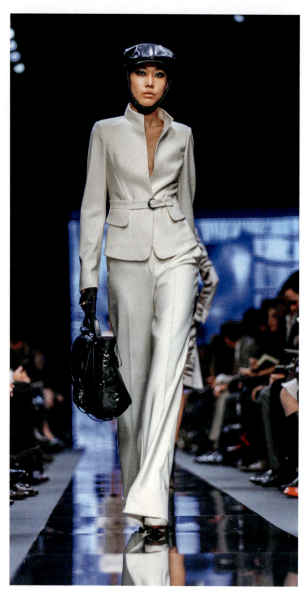

OPPOSITE Models showcase feminine A-line dresses in a simple palette of black, white and red for the Celine S/S 2008 collection.

LEFT Celine's A/W 2007 collection was full of French chicness, in a mostly black and white palette.

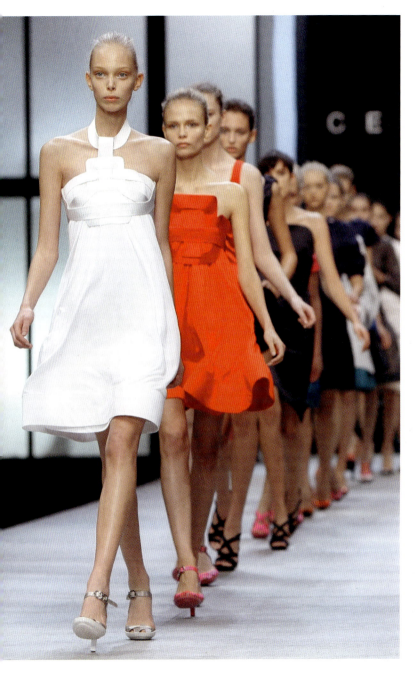

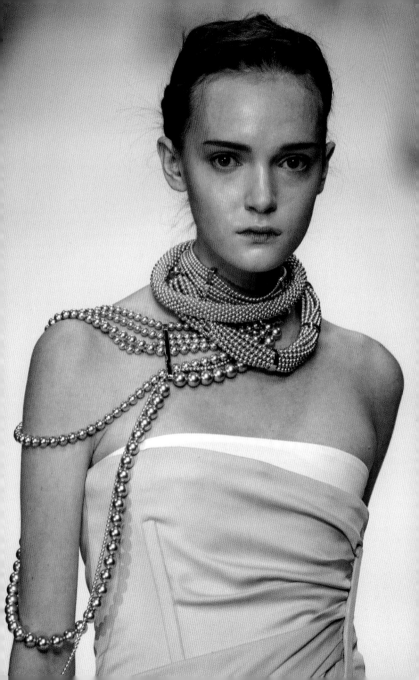

OPPOSITE Ivana Omazić's last Celine collection – for S/S 2009 – was showcased in Paris in October 2008.

What followed was a revolving door of back-to-back steady collections that cemented Omazić's perspective at Celine. Autumn/Winter 2008, for example, relied again on a black-and-white palette, as well as the designer's signature feminine frocks, slim cropped leather jackets and voluminous skirts. But when it was time to show the Spring/Summer 2009 collection, news of Omazić's exit at Celine was already out, marking this lineup as the designer's last at the Parisian label.

Omazić showed a sportswear-heavy collection once again at Celine, doubling down on her signature silhouettes. The thought of a replacement – Phoebe Philo – having been announced already, seemingly did not deter Omazić's point-of-view at the brand. This time, with a "tribal" twist: prints in the form of Polynesian tattoos, beaded skirts, layered necklaces and feathered details on cropped jackets and skirts. While the collection was categorized by critics as "commercial", it was not missed among editors that Omazić was put in a tough circumstance as she presented her final collection.

Kors's aftermath presented challenges for the brand as it attempted to find its footing and sartorial identity past its founder and first creative director. Yet, Menichetti and Omazić put to the test the brand's identity crisis, attempting to forge new paths that blended their respective design perspectives and the label's heritage. No one could've predicted what happened next.

THE PHOEBE PHENOM

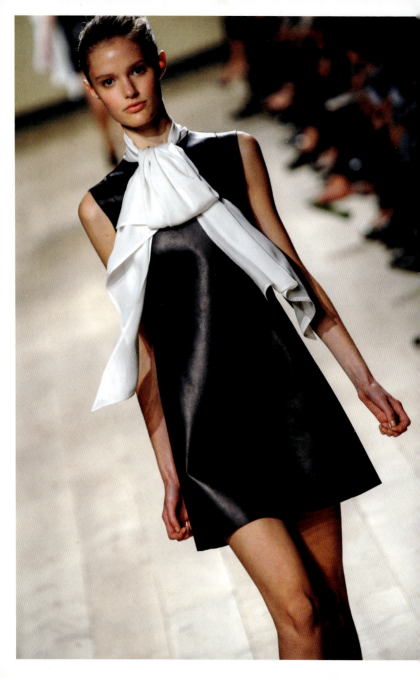

PHOEBE PHILO'S TENURE BEGINS

> "I believe in things being beautifully made but at the same time practical" – *Phoebe Philo*

Celine's dazzle from the Michael Kors era was fading by the time Ivana Omazić left the brand. LVMH needed a new designer to revive the Parisian label. But not just anyone would do. Fellow luxury brands were helmed by designers whose star factor was on a par with celebrities – Marc Jacobs at Louis Vuitton, for example – and it made for big business. That's when LVMH chose Phoebe Philo.

At the time, the French-born English designer was 35 years old and on a three-year career break spending time with her family. A graduate of Central Saint Martins, Philo's résumé was picture-perfect for the top job at Celine. Right after graduation, Philo joined Chloé where she served as a design assistant under Stella McCartney in the late 1990s. She became creative director at Chloé from 2001 to 2006, succeeding McCartney and earning a cult following of her own, thanks to her unique brand of minimalism. Back then, she was signalled as the "Chanel of her generation" by fashion critic Cathy Horyn.

OPPOSITE A model showcases the Celine S/S 2010 collection.

It didn't take long for Philo to do the same at Celine, launching a tenure that would redefine the brand forever.

But the designer's knack for female-forward clothing first started when she was a young kid. The daughter of a property manager father and a graphic designer mother, Philo's dip into fashion came when she customized a leotard because she wanted it to look like Madonna's. It was a few years later that her parents got her a sewing machine, from which she began sewing her clothes. Once she enrolled at Central Saint Martins, Philo felt a strong connection with 1990s minimalist designers like Jil Sander and Helmut Lang, a fascination that fuelled her focus on making practical clothing. "I've always had a sense that if I can't wear it, what's the point?" she told *T Magazine*. By 2001, she had taken over as creative director at Chloé after her Central Saint Martins' classmate Stella McCartney left to start her own label. But in 2006, Philo took a break, largely because she had just given birth to her first child and had been commuting from Paris to London for years.

BELOW Designer Phoebe Philo took the lead at Celine after a short break, following her tenure at Chloé.

OPPOSITE A model presents the Celine A/W 2010 collection at Paris Fashion Week.

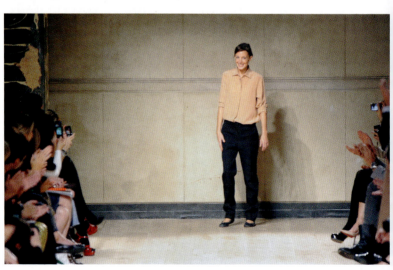

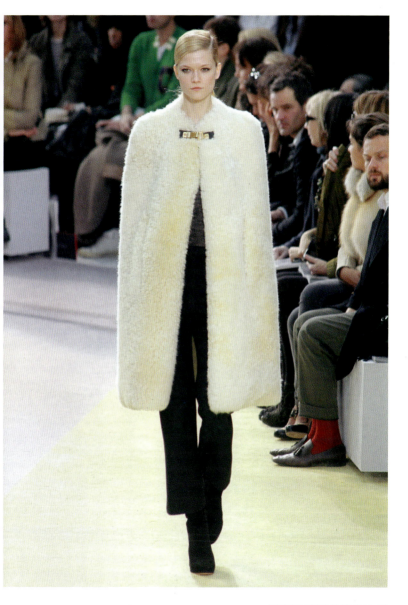

When LVMH knocked on her door, Philo was ready for a comeback. Although launching her own label might have been alluring, she settled for Celine because it allowed her to do it all on her terms: a London base and full control to rethink the brand with a team of her own. Philo started at Celine in 2008, focusing on building a team in London's Cavendish Square and revamping the brand's marketing and branding.

Philo's debut at Celine shed layers set by her predecessors with the brand's Resort 2010 collection. Long gone were the ultra-feminine frocks brought on by Omazić and layered gold

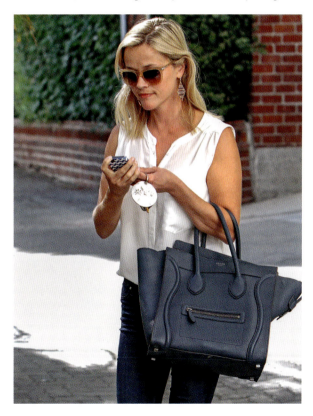

OPPOSITE Phoebe Philo's brand of minimalism quickly became the defining look of her era.

RIGHT
Actress Reese Witherspoon carries a Celine Luggage handbag.

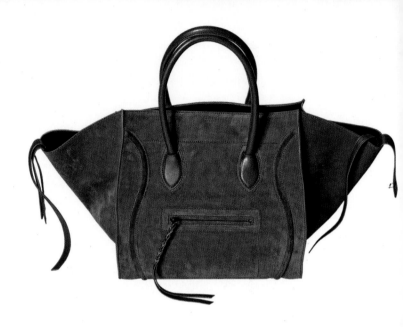

ABOVE Phoebe Philo introduced a few models of handbags that boomed during the 2010s.

jewellery from the Kors era. Instead, Philo decided to focus on building a wardrobe for her soon-to-be customers, forgoing the usual statement-making pursuit of debut collections. "I wanted to sort things out. This feels like a good solid start," Philo explained to *Women's Wear Daily* at the time. That "start" came in the form of bold-hued cropped trousers and draped tops, paired with tuxedo-style blazers worn over the shoulders. Reviews were quick to call Philo the next "It" designer. *Vogue*'s Nicole Phelps described the collection as a "confident, spot-on debut", highlighting that, while the clothes felt like a grown-up departure from the designer's days at Chloé, they were still "unmistakably Philo".

By the time October arrived, the buzz around Philo's first Celine runway had risen. As Philo's Celine came to life on the runway, it was clear her bet was on sophisticated utilitarianism: sleek leather minidresses, chic wide-leg trousers, flowing capes,

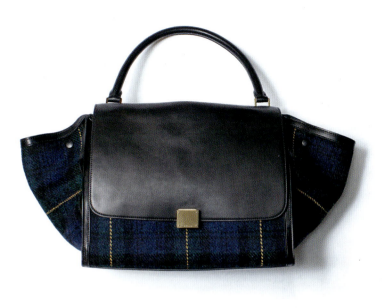

ABOVE
A Celine Trapeze handbag, a model introduced by Phoebe Philo.

trench dresses – all in a pared back, minimalist palette of neutrals contrasted with eye-catching royal blue and emerald green. *Vogue*'s Sarah Mower described the collection as an attempt to "make classy utilitarianism sexy", a mission in which she succeeded.

But it wasn't just the clothes making a splash. At Chloé, Philo had built a reputation for launching some of the brand's biggest "It" bags. One of them is the Paddington – launched in 2005 – which *The Telegraph* called "the most wanted accessory in the history of the fashion business". After all, the frenzy caused all 8,000 samples to sell out before they even made it onto shelves. When Philo debuted at Celine, a handbag release was sure to come too.

Enter the Luggage bag, Philo's first-ever handbag for Celine, debuting in 2009. At first glance, the oversized tote bag seemed like just another leather accessory, but it was its expandable

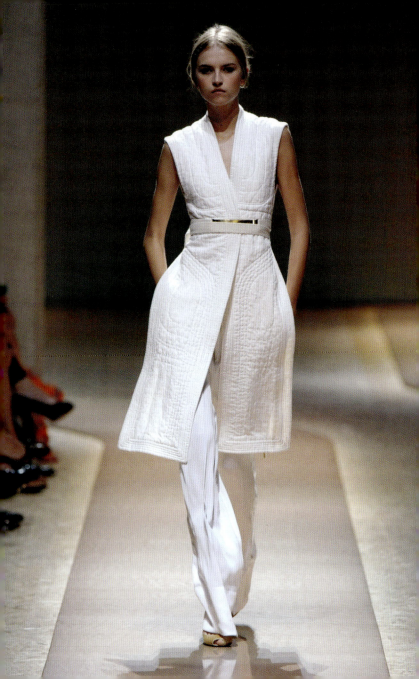

RIGHT Philo's Celine was heavily defined by the designer's take on bold colour palettes.

OPPOSITE A model presents the Celine S/S 2011 collection, which included separates with an artisanal feel.

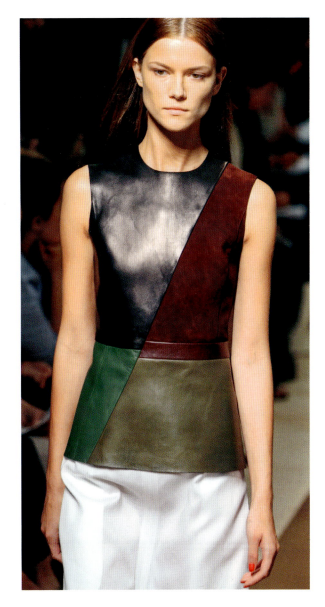

sides and striking asymmetrical lining that made it a must-have. It exhibited what Philo's Celine was all about – servicing women in their quest through modern life.

The bag also had an element of Celine heritage as the design was inspired by a piece of luggage from the brand's 1970s lineup. And when it was time to advertise it, Philo opted to do so for the Spring/Summer 2011 collection with models Daria Werbowy and Stella Tennant holding on to the purse in a campaign shot by Juergen Teller. Soon it was in the hands of every A-list celeb at the time, from the Olsen twins to Kim Kardashian, as well as fashion editors who lusted after the two-handle tote. Around the same time, Philo released the Phantom and Trapeze bags, which held a similar look and feel to the Luggage with expandable sides and oversized tote silhouettes.

Soon, the new Philo cult had emerged at Celine. And the industry accolades came with it. In 2010, Philo won Designer of the Year at the British Fashion Awards, and in 2011, took home the International Award trophy at the CFDA Fashion Awards.

While the minimalist aesthetic and luxe sportswear enthused customers, critics and celebrities at first, it was Philo's seeming freedom to experiment that quickly proved the designer was not a one-note wonder. The Spring/Summer 2011 collection was an explosion of colour with silk separates in bold prints, a leather orange minidress worn over white trousers, and frayed cream tops – all carrying an artisanal feel that seemed worlds apart from the metropolitan chic uniform Philo had first presented at Celine. It kept people on their toes. Throughout her time at Celine, Philo did just that: jolt up onlookers.

Birkenstock-like sandals with furry insides would do the trick. That's exactly what Philo put on the runway, breaking new ground for the Celine woman. The lineups of tailored

OPPOSITE A Celine Trapeze handbag, one of the brand's most popular accessories during the 2010s.

OVERLEAF The Trapeze handbag was available in a wide range of colour combinations and textiles.

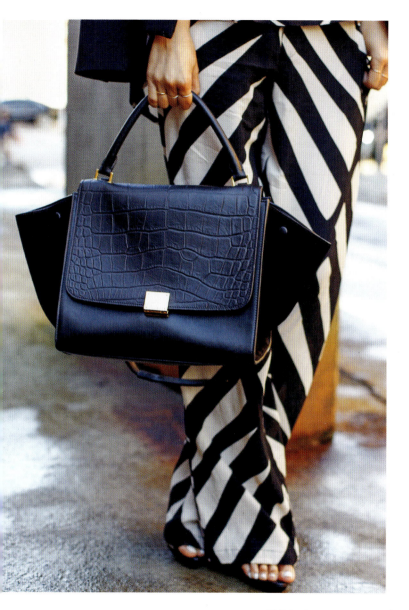

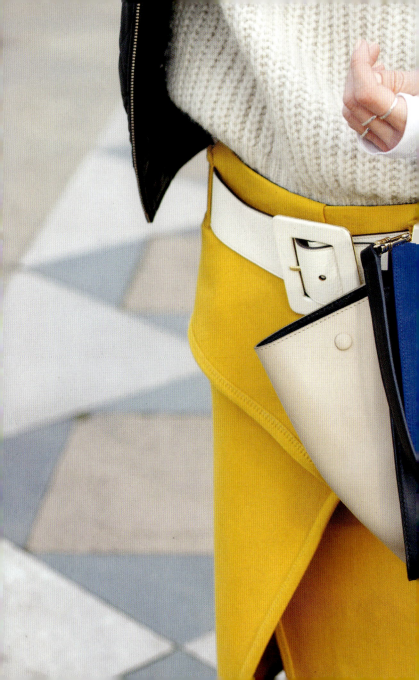

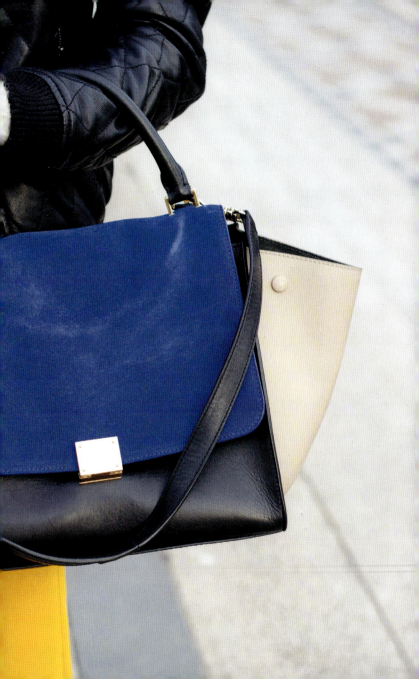

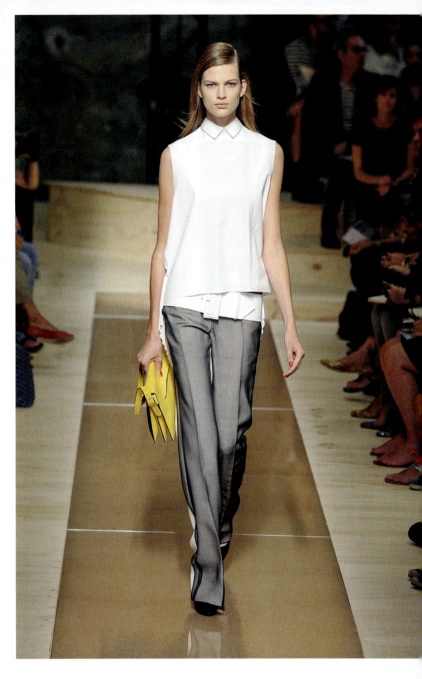

RIGHT Model
Daria Werbowy,
one of Philo's
biggest muses,
was featured on
several Celine ads
during her tenure.

OPPOSITE
A model presents
the Celine S/S 2012
collection, which
featured flowing
silk trousers
and a dominant
white palette.

OVERLEAF Models
showcase the
Celine S/S 2013
collection, which
was full of loose
silhouettes.

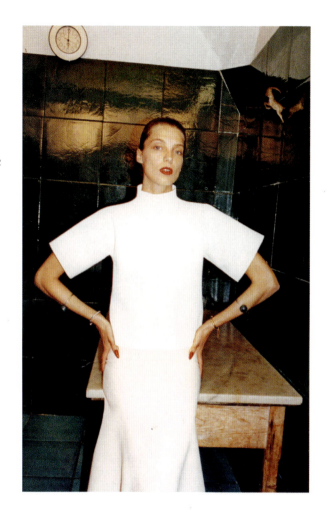

CÉLINE

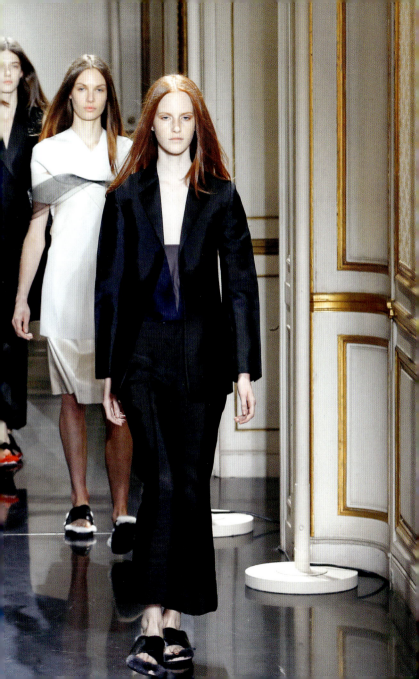

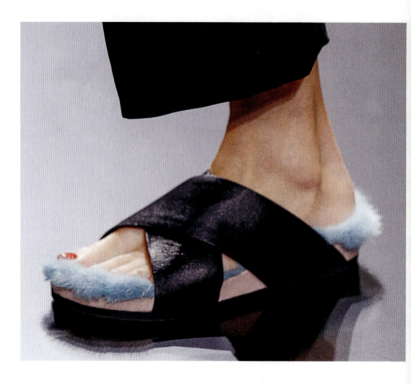

ABOVE Philo's furry-soled shoes became an instant hit.

suiting, neutral palettes and mostly work-ready clothing had proven to be Philo's stronghold, but many wondered if there was room for her Celine woman to run on the wilder side. For Spring/Summer 2013, there were loose silhouettes and a general relaxation felt throughout the collection that signalled a shift. But it was the footwear that revealed its new quirks: furry pumps in flashy red and striking yellow; and strapped flat sandals with fuzzy insoles in black and bold blue. The shoes caused some to query where Philo was going with this. Writer Jonathan Square questioned in his review if they were "furry or fugly". But by the time they hit stores, it was clear that Philo had unleashed yet another trend.

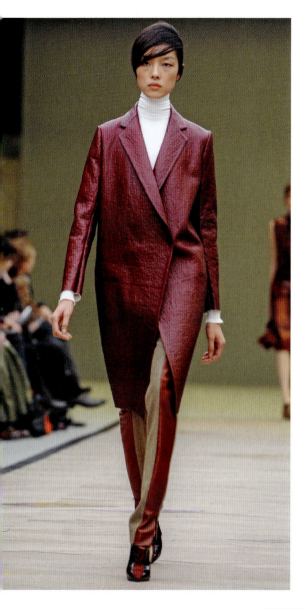

LEFT A model presents the Celine A/W 2011 collection, which included classic statement coats in vinyl and leather.

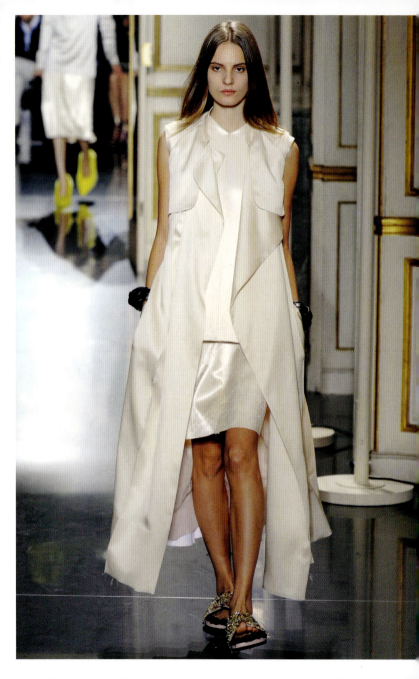

RIGHT A model presents the Celine A/W 2014 collection, which had a menswear influence, while keeping subtle feminine touches.

OPPOSITE The Celine S/S 2013 collection was marked by loose silhouettes and a more relaxed take on minimalism.

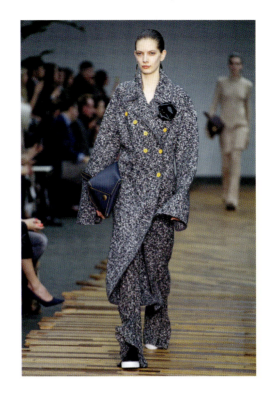

The Spring/Summer 2014 collection is a good example – an exercise in colour exploration that saw the designer get more playful than ever before. Inspired by Hungarian photographer-sculptor Brassaï, Philo's lineup featured aggressive brushstrokes and a saturated colour palette that seemingly mimicked the more graphic and bold world of graffiti. Models wearing long oversized T-shirts in colour-blocked brushstroke prints walked down the runway to the beat of George Michael's *Freedom*. Yet, she found a way to keep her signature style in place, building a bridge between whimsy and minimalism in a lineup *Vogue* described as "free, easy and fun".

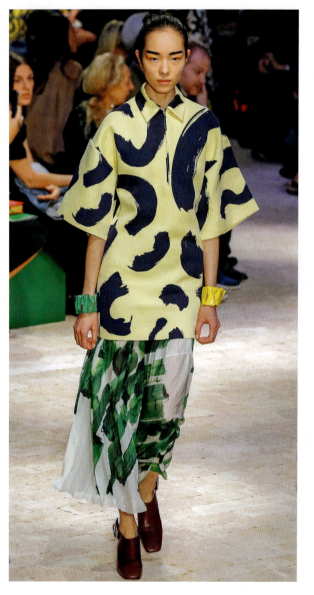

LEFT Celine's S/S 2014 collection was inspired by Brassaï, a Hungarian photographer and sculptor, with its bold brushstrokes.

OPPOSITE Philo's Celine handbags were marked by a general lack of logos.

OVERLEAF Models showcase the Celine S/S 2015 collection, which mainly prioritized career-minded women, while keeping an element of individualism.

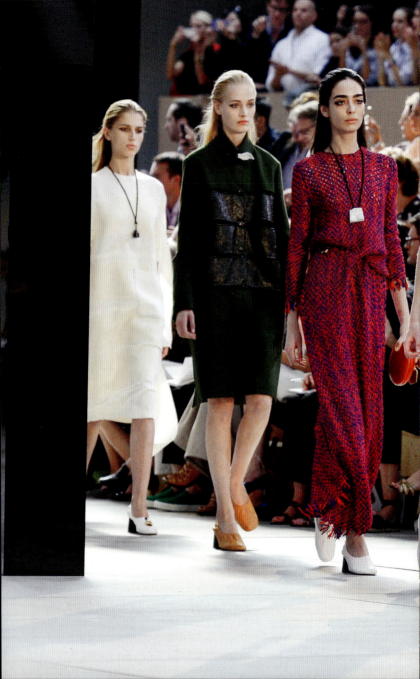

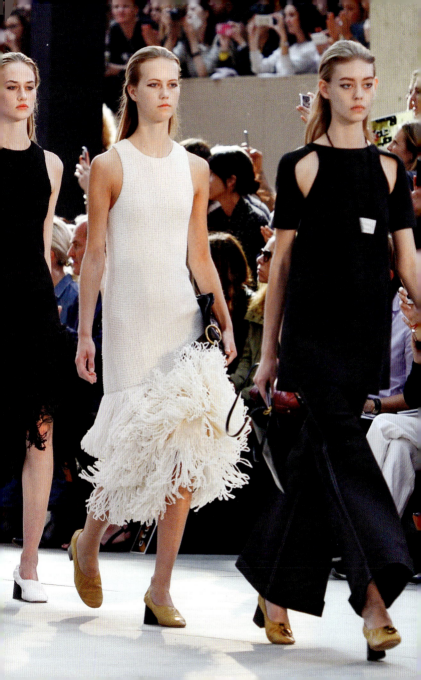

Yet, the thing about Phoebe Philo's Celine is that just as people fawned over a contrarian new route, she'd burst back to basics. Autumn/Winter 2014, for example, pared back the Spring/Summer collection's foray into explosive colour combinations to explore a different kind of dynamism: menswear. Inspired by Dada and surrealist artists Hannah Höch and Lee Miller, Philo looked at how revolutionary it once was that women wore men's clothing through the lens of the 1930s and 1940s. "I very much wanted women in men's clothing, but it was a complex idea so we brought it back to a quite feminine silhouette," she told *Vogue*. The collection was filled with nods to menswear put on its head by ultra-feminine details: double-breasted black coats with rose-shaped brooches; and classic trousers with boat-neck long-sleeved tops.

The collection underscored another pillar of Philo's Celine: women, or as the designer's most fervent fans are called, "Philophiles". "I like the idea that at Celine we attract a very varying group of women. They are all different, but with the common thread of an appreciation for clothes that suggest something new but made to last far beyond fast-trend fashion," Philo told *The New York Times*.

The designer's approach to clothes for the everyday, working woman was more than just an exercise in practicality. While fashion is often painted as a frivolous endeavour for women, Philo dared to scream out loud – via her collections – just how smart clothing choices can be, and therefore, the women wearing them. "So few designers think inside the heads of women, and fewer still respond to the unanswered questions in such a stylish yet thoughtful way," wrote critic Suzy Menkes of Philo's Autumn/Winter 2010 collection for Celine.

This idea is perhaps best exhibited by Celine's Spring/Summer 2015 campaign, featuring French dancer Marie-Agnès Gillot, model Freya Lawrence and writer Joan Didion. It was

OPPOSITE Writer Joan Didion starred in Celine's S/S 2015 ad campaign.

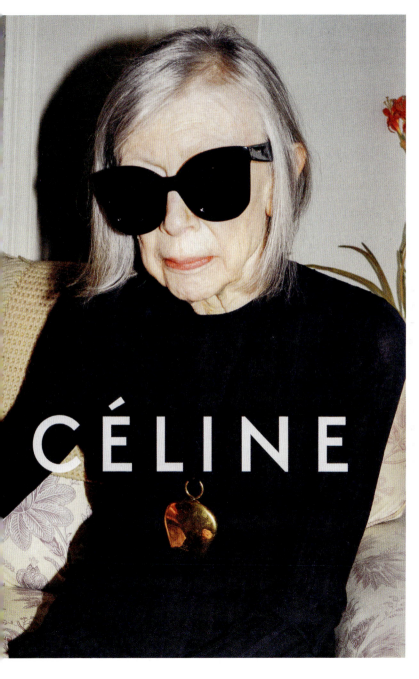

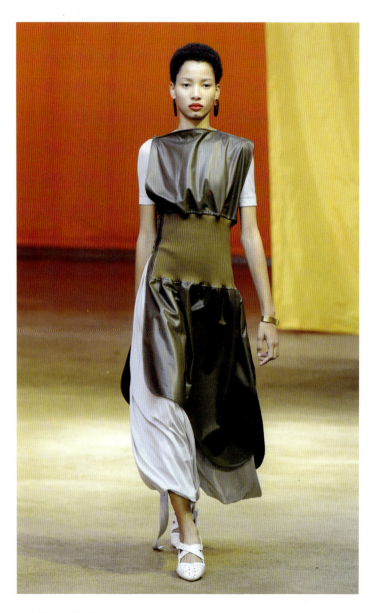

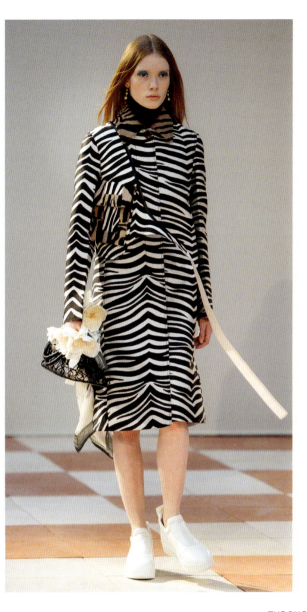

OPPOSITE
A model presents the Celine S/S 2016 collection, which focused on the waist and exaggerated proportions.

LEFT Philo's focus on building a wardrobe for everyday women earned her a cult following at Celine.

the image featuring the late American writer – appearing in a black top and skirt with matching oversized sunglasses – that broke the Internet once it was unveiled, largely because its subject was unorthodox but equally fitting to star in an ad for Philo's Celine. Aside from a 1989 Gap ad, Didion had not made many other appearances in the fashion world, even though her style and taste have been hugely influential for designers and editors. That it was Philo's Celine that managed to attract Didion's attention speaks volumes about the designer's commitment to making clothes and accessories that are not just practical, but much like the writer herself, perpetually cool.

Philo's next few seasons at Celine proved to be an autobiographical depiction of a woman who has found freedom in her work. By that point, she had helped increase Celine's revenue fourfold, according to the *Wall Street Journal*, so there was freedom to play around. Colourful, joyful and unabashedly humorous, the clothes and accessories from Autumn/Winter 2015 to Spring/Summer 2017 saw Philo in a complete turn of moods. "The best part about this job is finding out more about myself," she told Tim Blanks in 2015. "It gets deeper and deeper into the roots." Perhaps that's why these collections carried out a raw whimsy that proposed a more spirited version of Philo's Celine woman. Pom poms, fur-lined coats, animal prints, lace-trimmed camisoles, blood-red suits and trompe l'oeil details. As filmmaker Sofia Coppola once told *The New York Times Style Magazine*: "It's not based on some weird idea of what a woman should be."

By the Spring/Summer 2017 collection, it was clear Philo's Celine had built the kind of culture-shifting power many designers aim for. And she did so by simply providing women with forward-thinking, functional and chic clothing they had craved from the fashion industry for decades. The collection

OPPOSITE Bold colour palettes took centre stage for the Celine S/S 2017 collection.

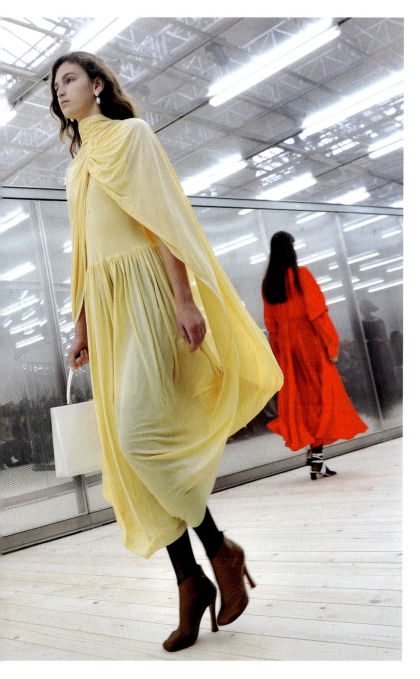

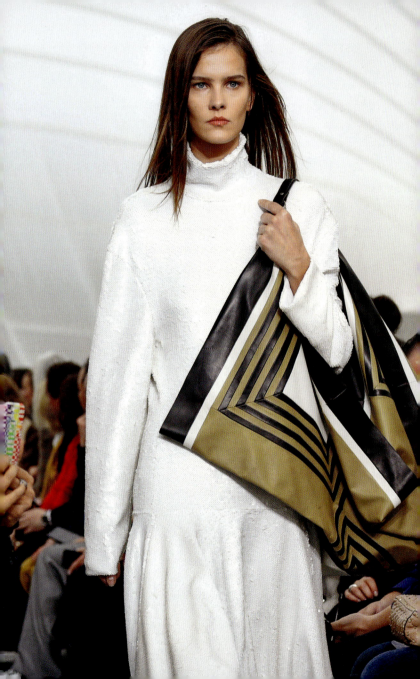

meshed together Philo's years of exploration at Celine: clashing colour combinations of mint green and blood red, flowy caped dresses with ankle boots, frocks that looked as if they had just been painted on, easy cut-out gowns that looked just as good for the weekend as for a gala. It seemed as if the Celine woman was established and well on her way to building a legacy inside the Parisian brand. Around that time, Philo's once eloquent backstage elaborations about her collections had gone silent. The media-shy designer had resolved not to talk to the press before or after her fashion shows, letting the clothes do the talking for her.

Less than 10 years into her tenure, Philo was ready to bow out. And she did just that in December 2017. "Working with Celine has been an exceptional experience for me these last 10 years. I am grateful to have worked with an incredibly talented and committed team and I would like to thank everyone along the way who has been part of the collaborations and conversations…it's been amazing," Philo wrote in a statement to her team, provided by *Women's Wear Daily*.

Just two months before, Philo had inadvertently shown her last collection at Celine. She told *Vogue* at the time that she was feeling "optimistic" and wanted her collection to feel like a "celebration". Cryptic messaging that would eventually lead everyone to understand Philo might have already been on her way out. The lineup, though, did not suggest any sort of remembrance or farewell: silk-draped dresses with leather bustles, Western-inspired trench coats and oversized skirt suits were all in the mix. The inspiration for the collection, though, did give away clues that Philo was putting a bow on her legacy. She told *Vogue* that she was inspired by the Celine clothes of the 70s and 80s, specifically the glamour of older women who shopped at Celine. According to writer Sarah Mower, it was that archetype that first interested Philo in joining Celine.

OPPOSITE A model presents the Celine S/S 2018 collection, full of draped dresses and leather detail.

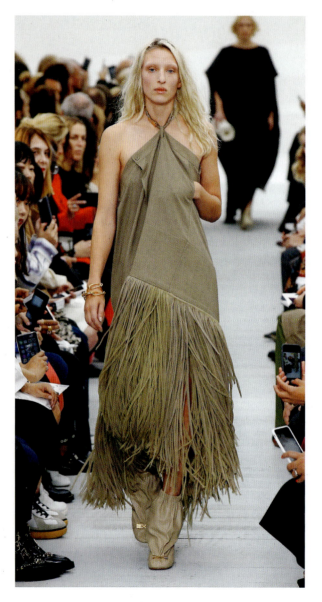

LEFT Phoebe Philo's tenure at Celine came to an end after nearly 10 years. Her last collection included pieces inspired by the Celine clothes of the 70s and 80s.

OPPOSITE S/S 2018 signified Philo's last collection at Celine.

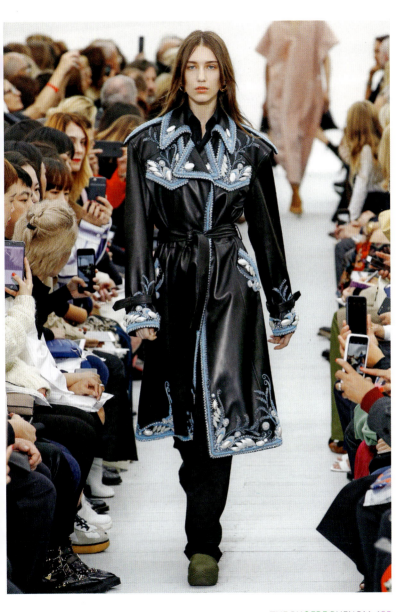

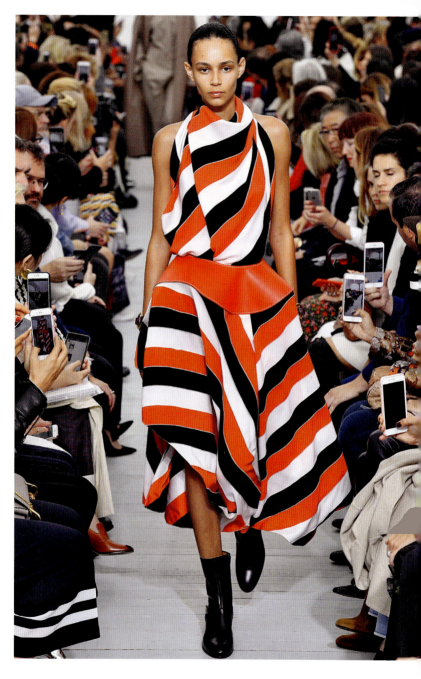

When December rolled around, the industry was shocked and saddened. Once again, Philo had cultivated a community around her work, providing women with their everyday uniforms and the industry with a front-row seat into what it's like to revitalize a brand the right way. But just like she had done when she left Chloé, Philo opted to exit while the going was still good. LVMH did not immediately announce a successor, but Philo's shoes would eventually be filled by another star designer: Hedi Slimane.

But that was far from the end of Philo's Celine era. After Slimane's Celine debut the following year, which took the brand in yet another transformation, the resale value for Philo's Celine increased by 30 per cent, according to *The Business of Fashion*. Leading up to Slimane's show, and following a few controversial changes at the brand, the resale platform Vestiaire Collective saw a 275 per cent increase in Celine searches and a 43 per cent increase in sales.

The frenzy to get Philo's Celine-era work was evidence of her mark on her customers' wardrobes. But also in the grand scheme of fashion history, a period which came to be known as "Old Celine", thanks to social media accounts that started documenting Philo's time at the brand, differentiating it from Slimane's. A second resale frenzy emerged when, after years out of the spotlight, Philo finally announced her namesake brand (its first collection sold out in hours despite having bag prices averaging $5,000). Searches for "Old Celine" following the release increased by 70 per cent on eBay, according to *Harper's Bazaar*.

Philo outlived Celine, becoming a worldwide famous name, thanks to her signature minimalism and approach to putting women's taste and needs above all else. But her Midas touch on the brand has stayed with it to this day.

OPPOSITE A look from S/S 2018, Philo's last collection for Celine. By the time she left the brand, her fans had been renamed as "Philophiles".

OVERLEAF A Celine retail store in 2016.

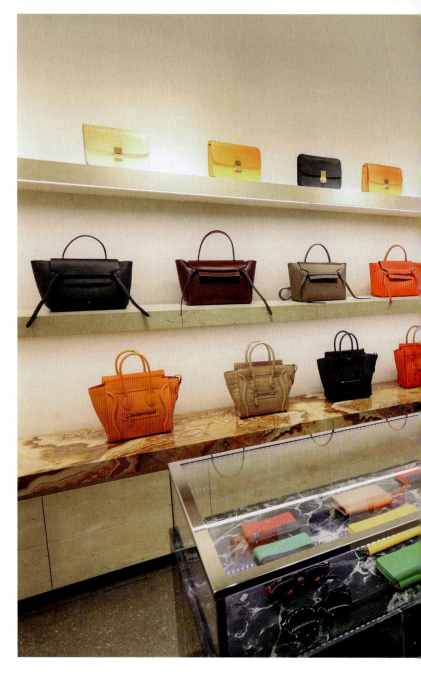

NEW CELINE

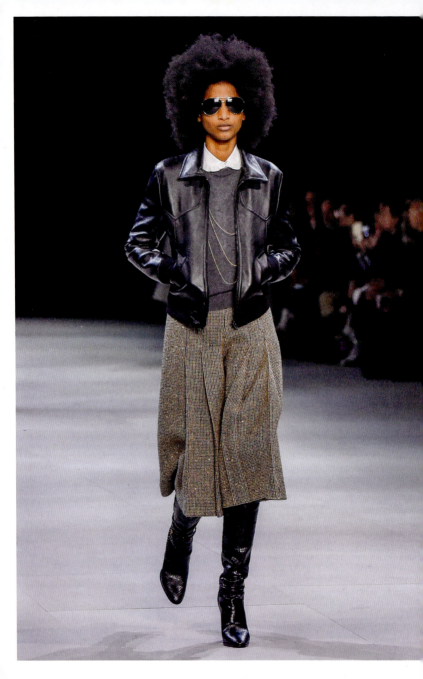

THE DISRUPTION OF HEDI SLIMANE

Phoebe Philo's departure from Celine shook the fashion industry. Her seismic brand shift had established Celine as one of the modern women's most sought-after labels. And while it could certainly try to retain some of its signature elements without the designer, Philo's influence was the secret ingredient. If Philo was not responsible for its designs, what was Celine?

It seems LVMH knew this. Trying to replicate Philo's success would be characterized as a copy, never quite living up to its originator. So the brand hired a designer who would transform the brand once again. His name was Hedi Slimane.

To fashion fans and insiders, Slimane was far from a stranger. His résumé was an amalgamation of luxury fashion houses that would make any aspiring designer's dreams come true. Known for his signature skinny silhouette, Slimane's career started as an assistant in fashion marketing at Yves Saint Laurent during the 1990s, a role he outgrew to become ready-to-wear director of the men's collections by 1996. By 2000, Slimane moved to Berlin, where he took up a residency at the Kunst-Werke Institute for Contemporary Art until 2002. At the same time, he became creative director for Dior Homme until 2007, leaving fashion to focus on photography projects.

OPPOSITE A model presents the Celine A/W 2019 collection, which included A-line knee-length skirts and leather jackets.

But he returned to Yves Saint Laurent in 2012, taking up creative control of both the women's and men's collections.

Slimane's tenure at Saint Laurent had been quite controversial. Despite having been at the brand for less than 10 years, the designer made some bold choices. One of them was letting go of the brand's legacy "YSL" logo and dropping the "Y" to rebrand the label as simply "Saint Laurent". His clothes also raised eyebrows, as the designer stuck to his skinny silhouette with silky minidresses, paired with leather jackets or cropped blazers, and shown on equally skinny models. Slimane also rumbled with critics openly. Cathy Horyn, who worked at *The New York Times* back then, wrote of his first collection that "the clothes held considerably less value than a box of Saint Laurent labels". Slimane penned an open letter on X (previously Twitter) responding to Horyn, calling the critic a "bully" and banning her from Saint Laurent shows. But as controversial as Slimane's Saint Laurent era might have been, it also made big bucks. Sales passed the $1 billion mark during his tenure, according to Kering, the label's parent company.

With this scenario as the background, LVMH's choice to appoint Slimane at Celine in February 2018, which came with news that the designer would also release menswear, couture and fragrances under the label, also sparked outrage from the beginning. Throughout her years at Celine, Phoebe Philo had pushed the brand into a feminist agenda, freeing women in their clothes and giving space for their ideas and intelligence to be put centre stage. Philo's work was also an outlier in fashion, an industry where the majority of labels are helmed by men and which is often criticized for promoting the male gaze. So going with Slimane – whose penchant for dark colours and skin-tight silhouettes had become his signature – felt like a jab to Philophiles, who had found an oasis in Celine and were now being left high and dry. Or so it seemed.

OPPOSITE
Designer Hedi Slimane quickly disrupted Celine's branding and logo.

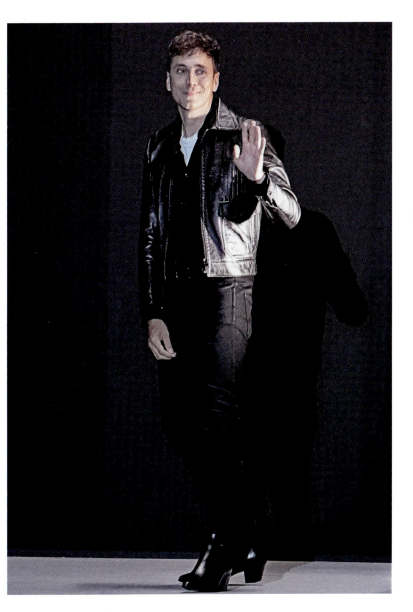

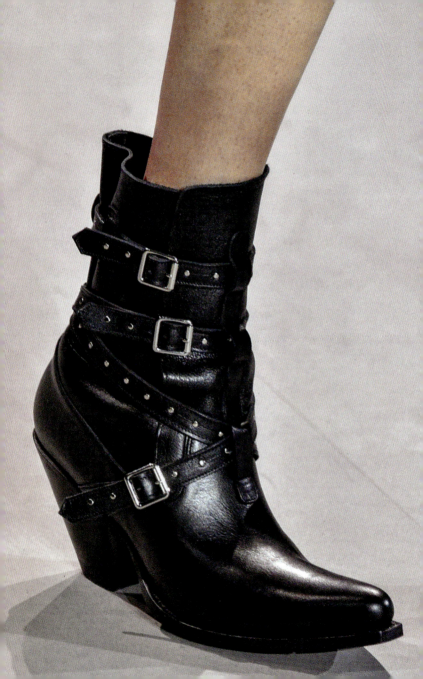

Before Slimane showed his first collection for Celine, he revealed a new logo and dropped the accent from the brand's name, mimicking the label's look in the 1960s. Of his decision to drop the accent, he told *Le Figaro*, "It's about putting the church back at the center of the village. It's orthodoxy, quite simply." Slimane also debuted his first handbag for the brand: the Celine 16 handbag, a top-handle bag with a lock charm and long strap that referenced the brand's Paris address – the Hôtel Colbert, at 16 Rue Vivienne – with its name. It quickly became one of the season's "It" bags, despite not being available for sale yet, thanks to the endorsement of celebrities like Lady Gaga and Angelina Jolie.

A month later, in October 2018, Slimane presented his first collection, titled "Paris La Nuit", embodying the kind of rockish aesthetic that the designer had cemented as his signature for years. The show opened with a black minidress that featured voluminous sling sleeves and a polka dot print

BELOW A look from the Celine S/S 2019 collection.

OPPOSITE Philo's minimalism was substituted by punk rock-inspired accessories and silhouettes that were more in line with Slimane's design DNA.

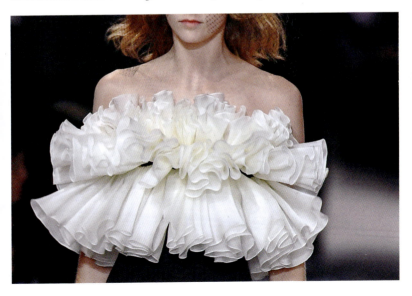

RIGHT A model presents the Celine S/S 2019 collection, which took Celine fans by surprise.

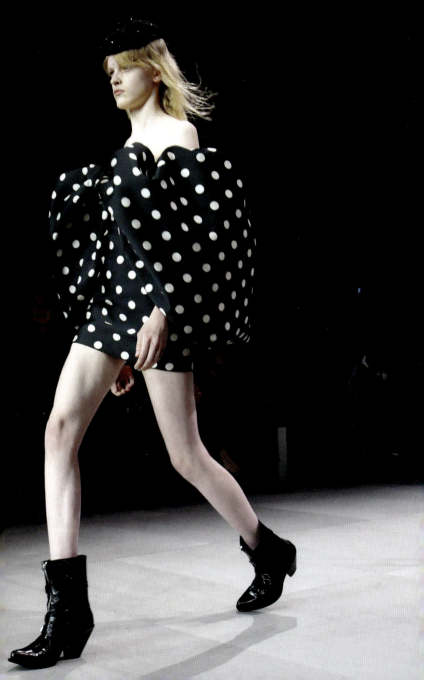

and was followed by numerous iterations of skinny tie suits, leather jackets, cropped blazers, bubble-hem dresses and metallic frocks. While the contrast might have seemed jarring, especially the elevated hemlines and sudden influx of menswear clothing, Slimane revealed that all the looks worn by male models were unisex and would, therefore, be available for sale to anyone.

Yet, as *Vogue*'s Sarah Mower wrote of the collection, "Slimane's aesthetic worldview doesn't include the class of women who were prepared to pay full price for anything Philo designed". Instead, Slimane's Celine positioned to move away from the workplace and into the nightclub, a vision many critics did not appreciate. "A brand that was once thoroughly identified with a peerless instinct for what women want in fashion all of a sudden looked like a gust of toxic masculinity," famed writer Tim Blanks penned for *The Business of Fashion*. Other critics like *The New York Times*'s Vanessa Friedman thought the collection looked too similar to Slimane's past work: "The lyrics that most came to mind were 'Mamma Mia! Here we go again'," she wrote. A month before the debut, Slimane seemed to have anticipated this backlash, telling *Le Figaro*: "You don't enter a fashion house to imitate the work of your predecessor, much less to take over the essence of their work, their codes and elements of their language. The goal is not to go the opposite way of their work either. It would be a misinterpretation."

When Slimane revealed his Autumn/Winter 2019 collection for Celine the following March, things looked a little different. Whereas his first lineup made a personal statement, the Autumn/Winter 2019 collection showed the designer could potentially look beyond his signature and into Celine's past, before the house became a fashion mainstay. There were 70s and 80s-inspired silhouettes that included A-line knee-length

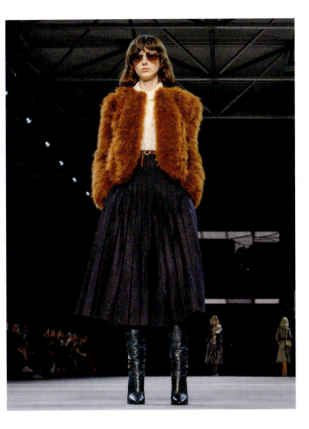

LEFT A model presents the Celine A/W 2019 collection, which included androgynous jackets paired with simple skirts.

skirts, ruffled dresses and plaid blazers, mixed with Slimane's signature leather jackets and skinny pants. As *Vogue*'s Sarah Mower wrote, models were wearing "what the original Celine was and had meant to every French bourgeois woman" before LVMH's acquisition. Slimane seemed to be poking fun at the fashion world's positioning of Philo's Celine as "old Celine" – or even real Celine – by showing the brand's roots, and as writer and editor Nikki Ogunnaike put it, meeting "Philo fans somewhere in the middle".

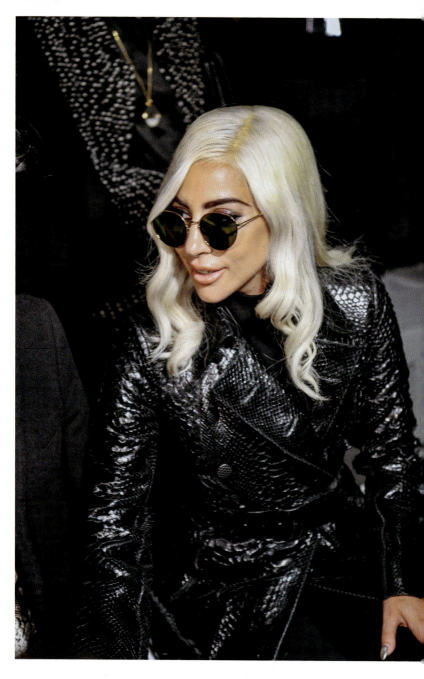

Slimane's intent on highlighting the *old* old Celine went beyond addressing controversies or Philophiles. Instead, he focused on bringing back some of the lost symbols that Celine first made its name with, like its interlocked double-C logo and chain-link motif. The Autumn/Winter 2019 collection included an amalgamation of the double-C and chain-link motif pieces, from scarves and layered necklaces to gold straps on purses and handbag clasps. The accessories revealed yet another difference between Philo and Slimane: minimalism was out, and logos were in. The Autumn/Winter 2019 collection, for example, featured one of Slimane's bestselling handbags for Celine: the Triomphe bag, a rectangular shoulder bag that features a double-C clasp on the front. Whereas Philo's handbags featured no visible logos, Slimane opted to give customers a chance to put Celine on full display. It was a vision shared with many of the other luxury houses at the time: Gucci, for example, had won big back then with its Marmont bag, which featured a double-G logo on its clasp.

It was clear from the beginning that Slimane was brought in to catapult Celine even more than his predecessors. According to *Quartz*, LVMH CEO Bernard Arnault told investors in 2018 that the "objective with [Slimane] is the next five years to achieve between €2 billion and €3 billion [in sales], possibly more". And in one year, he was on his way there. Sales at the brand increased to over $600 million in 2019, largely thanks to the new lineup of handbags and accessories released by Slimane, which included the Celine 16 top-handle bag, 16 Besace crossbody bag and Triomphe shoulder bag.

Yet, 2020 proposed new challenges for Slimane and LVMH. The coronavirus pandemic, declared in March 2020, forced retail stores to close and customers to shelter inside their homes. A few days before, Slimane had presented the house's Autumn/Winter 2020 collection, which *The Guardian*'s Jess Cartner-Morley

OPPOSITE Lady Gaga attending the Celine show at Paris Fashion Week, September 2018.

highlighted as evidence of Slimane's "gift for making nostalgia modern". Rooted in the brand's 1970s era, the decade's classic silhouettes shone throughout the collection, including velvet blazers, floppy hats, ruffled necklines, polka dot shirts and knee-length shorts, carrying a youthful feeling that brought back Paris's mid-century revolutionary energy made for a modern-day customer. It was a resounding success with critics, whose take on the collection began to soften customers' first fears of a Slimane takeover at Celine.

Vogue's Sarah Mower described its menswear lineup as "rock-star glamour – the dream Slimane has been making come true his whole career", while *The New York Times*'s Vanessa Friedman called it "steeped in attitude: bourgeois alienation and cosseted rebellion". Yet, others remained sceptical of Slimane's model casting. "In the 90s, it might have been called 'heroin chic'; in 2020, I'd call it outdated," wrote Tyler McCall for *Fashionista*. It was yet another example of how polarizing Slimane's work can be.

As the pandemic continued, fashion shows were transformed into virtual presentations, which Slimane – a photographer and creative director in his own right – used to expand his Celine universe even further. From July to October 2020, he showed two back-to-back men's and women's lineups for Spring/Summer 2021 that merged fashion and sports with the brand's ever-evolving youthful feel. The menswear collection – filmed inside the Circuit Paul Ricard racing track in the South of France – included notes of grunge, varsity jackets, beanies and oversized patchwork blouses, blended with the designer's signature take on tailoring.

For the womenswear collection, Slimane filmed inside the Stade Louis II in Monaco, showing a lineup of the bourgeois staples that first made Celine famous, reworked for a TikTok-obsessed Gen Z. "With this collection, Hedi wants to show,

OPPOSITE
A menswear look from the Celine S/S 2023 collection, showcased at Paris Fashion Week.

RIGHT Slimane's era at Celine has been largely marked by his heavy use of logos.

through the youth and optimism, the hope in this uncertain time," read a statement sent via email to the press. It came in the form of Triomphe logo baseball caps, styled with cropped jackets and cropped jeans, as well as striped cropped tops with "Celine" emblazoned on the ribs, paired with athletic shorts and ankle boots. The casual feel was juxtaposed with high-end chain-strapped shoulder bags and classic ballet flats. "Like it or not, Slimane definitely knows how to tap into a youth culture, and these clothes are made for the types of kids going viral on TikTok," Tyler McCall wrote about the collection for *Fashionista*.

All the buzz was cut short by the pandemic's impact on the brand, however. Despite favourable reviews and the rising appeal of Slimane's Celine, sales decreased from $600 million to just over $400 million, according to LVMH's 2021 financial report.

Yet, Slimane's reputation of commercial success helped the designer turn things around with absolute hit collections in 2021 that solidified his footing at Celine. As fashion shows remained virtual, Slimane continued his runway video series, filming at the Château de Chambord for menswear and the Château de Vaux-le-Vicomte for womenswear. The latter was perhaps the buzziest of the two lineups, merging the Gen Z staples he had produced for earlier seasons with ultimate French girl classics that could be worn by anyone not on TikTok. A highlight of the collection was a model wearing a hand-beaded crinoline, paired with a leather bomber jacket and baseball cap – the perfect example of Slimane's youth-meets-luxury approach.

Slimane seemed to enjoy the runway film format so much that he kept it for a few seasons even when physical fashion shows resumed, as pandemic restrictions were eased. Those lineups kept Slimane's appeal at Celine flying high, with a Spring/Summer 2023 collection captured in Saint-Tropez that was revealed online outside of the Paris Fashion Week schedule.

Slimane's return to the runway came for Autumn/Winter 2023, when the designer took the brand to Los Angeles, California, in a move that paid tribute to the collection's indie rock 'n' roll feel. "It's probably time to go back to analog mode and get the filtered, ostracizing, theatricality of social media in perspective. A return to a sense of blunt and raw sincerity," Slimane said of the collection. His knack for nostalgia was back in the spotlight. Only this time, it was not a 1970s flashback, but rather a return to the 2000s era, right at the onset of the "It" bag craze, social media and cool girls like Alexa Chung and Chloë Sevigny. This gave way to model Kaia Gerber wearing a

tuxedo blazer with low-rise leather trousers and oversized black sunglasses while carrying an oversized handbag; slim suits on models, paired with ruffled tops and biker boots; concert-ready metallic fringe details on everything from dresses to jackets. All followed by performances from iconic 2000s indie acts like Iggy Pop, Interpol, The Kills and The Strokes.

Slimane wouldn't show another unisex womenswear collection for nearly a year. When he did, Slimane went back to the video format with a Spring/Summer 2024 collection set at the Bibliothèque Nationale, that included an amalgamation of archetypes – the bourgeois woman, the TikTok-cool girl, the grunge-leaning shopper, the indie sleaze groupie – he had been building up since settling in at the brand in 2018. "We are all characters in our own fiction. Might as well have the tools to dress for it," wrote *The New York Times*'s Vanessa Friedman of the collection.

For Autumn/Winter 2024, Slimane seemed to have closed a cycle at the brand by looking back to its past. The collection, titled "La Collection de l'Arc de Triomphe" and revealed via a video, paid tribute to the label's founder, Céline Vipiana, centring around 1960s silhouettes. Knee-high boots and platform Mary-Jane shoes accompanied a lineup of cropped jackets, pussy-bow blouses, chic skirt suits and cape dresses that brought an elevated take to Slimane's cool-girl uniform.

Though it may have started with a rocky reception, Slimane's tenure at Celine was one of the brand's most monumental episodes, both editorially and commercially. Sales soared well past the €2 billion goal set by LVMH, and despite Slimane's predecessors, Celine seemingly became synonymous with the French designer. Yet, by the spring of 2024, sources confirmed to *The Business of Fashion* that Slimane was tied in a contract negotiation with LVMH that could potentially end with the designer exiting the brand.

OPPOSITE
Slimane introduced menswear at Celine for the first time in the brand's history.

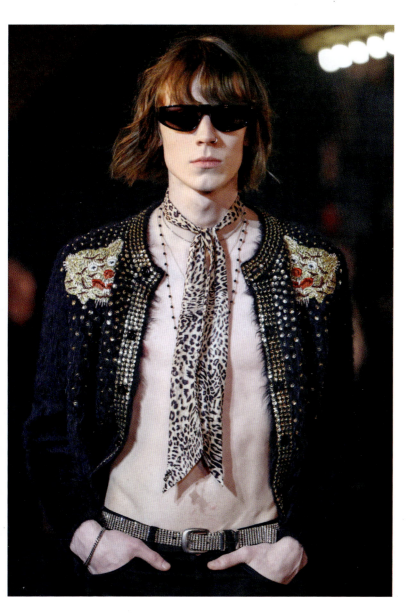

THE FUTURE
OF CELINE

A COMPLICATED LEGACY

For 80 years, Celine has been many things: a children's shoe shop, a bourgeois womenswear and leather goods boutique, a luxury starter brand inside one of the most successful conglomerates in the world, a minimalist haven and a highly commercialized youthful brand.

From its early days as a start-up business to today's global luxury mainstay, the changing times at Celine have tried to answer what defines this iconic fashion brand, each time proving that there is no right answer – only heritage.

As 2024 drew to a close there was another shift in dynamic. After Slimane confirmed his departure from Celine in October 2024, designer Michael Rider was appointed artistic director. Each time a new designer leads the brand, there is more material to reference and more codes to work with – from the iconic Triomphe logo that has been a defining emblem over the years to Philo's minimalist chic and Slimane's era of youthful

OPPOSITE Actress Carey Mulligan wearing Celine in 2023.

OPPOSITE Lady Gaga wearing Celine in 2024.

OVERLEAF Celine embraced Hollywood glitz and glamour in their A/W 2023 collection, with shimmering details and lots of black and gold.

renaissance. This heritage has enabled Celine to stay strong, while constantly shifting and evolving with the times.

Still, there are doubts that Celine can ever grow past many of its competitors, no matter who is at the helm. Though Slimane's era saw sales increase to €2.5 billion, the brand still lags behind other iconic French houses like Louis Vuitton and Dior. For decades, Celine has acted as a secondary character in the luxury fashion sphere that's continuously trying to reinvent itself through new symbols and designers. Yet, its secret sauce of everyday sportswear essentials and elevated accessories has proved to be a good canvas to maintain 80 years of heritage.

You could be forgiven for thinking that Céline Vipiana never envisaged the brand's current success. After all, it was started as a children's shoe shop. Yet, her decision to expand its categories and establish a trademark logo showed her ambitions were much larger, even if it was all rooted in core essentials. Celine's continuous evolution is evidence of the power of those basic principles, inspired by the everyday glamour of French women and decoded via its many creative directors. May it always look to them to see its future.

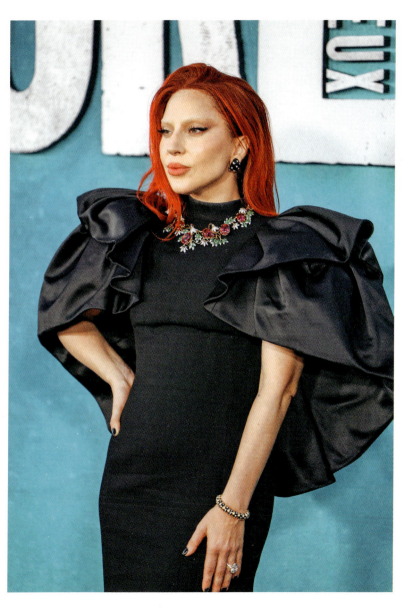

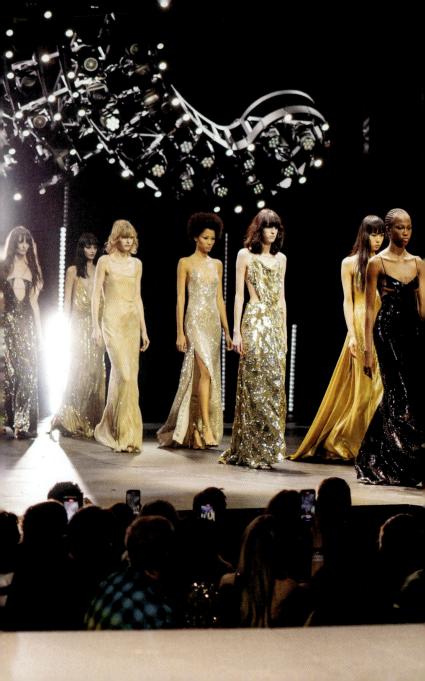

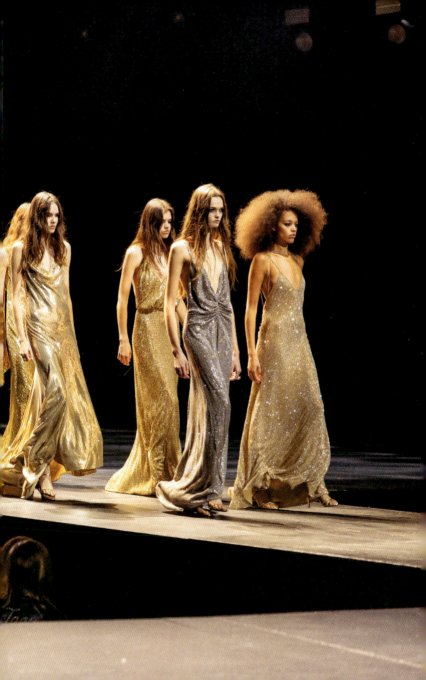

INDEX

Numbers in italics refer to pages where captions appear

accessories 22, 30, 31, 81, 141, 152
advertisements 22, 30, 98, *103*, 115, 118
animal prints 56, 67, 118
Arc de Triomphe 9, 29, 30, 146
Arnault, Bernard 25, 43, 56, 141

bags 10, *15*, 22, 28, 30, 31, *31*, 81, *94*, *95*, 111
 Boogie 30, 55
 Celine 16, 135, 141
 chain-strapped shoulder 144
 Classic Box 31
 "It" 52, 95
 Luggage 95–8
 oversize 146
 Phantom 98
 tote 48, 55, 95, 98
 Trapeze 31, *95*, 98, *99*, *100–1*
 Triomphe 31, 32, *32*, *36*, *37*, 38, *38*, 141
baseball caps 144, 145
beanies 142
belts 22, 30, 39
 chain 48
 double-strap 49
berets 81
Bergdorf Goodman (New York) 44
Bertelli, Patrizio 75
Bessette-Kennedy, Carolyn 67
Bibliothèque Nationale (Paris) 146
bikini bottoms 67
billboards *10*
Blanks, Tim 118, 138
blazers 74
 cropped 138
 plaid 139
 tuxedo-style 94, 145
 velvet 142
blouses
 patchwork 142
 pussy-bow 146
 see also shirts
bodysuits 49
boots
 ankle 144
 biker 146
 knee-high 80, 146
bourgeois fashion 14, 21, 67, 74, 139, 142, 151
Bowles, Hamish 48–9
branding 10, 32, 93, 132
Brassaï 109
British Fashion Awards 98
brooches 114
Bündchen, Gisele 30, *51*
Burberry 71
Business of Fashion, The 125, 138, 146
buttons
 double-C 30
 gold 25, 30

camisole tops 72, 118

capes 94
Caron, Leslie 67
Cartner-Morley, Jess 141–2
Celine
 resale value 125
 sales figures 52, 55, 125, 141, 145, 146, 152
 Triomphe logo 28–39
 under Hedi Slimane 131–47
 under Ivana Omazić 75–85
 under Michael Kors *42*, 43–67
 under Michael Rider 152
 under Phoebe Philo 89–125
 under Roberto Menichetti 71–5
Central Saint Martins (London) 89, 90
CFDA Fashion Awards 98
chain prints *62–5*, 67, 141
charities 22
Château de Chambord (France) 145
Château de Vaux-le-Vicomte (France) 145
Chloé 89, 90, 95, 125
Chung, Alexa 145
Circuit Paul Ricard (France) 142
coats 58–9
 double-breasted 10, 114

fur-lined 74, 118
fur-trimmed 48, 56
puffer 52
trench 30, 76, 81, 121
collections
　A/W 1998 44, *45*, *46*
　A/W 2000 48
　A/W 2001 49
　A/W 2002 *52*, 54
　A/W 2003 56, *57*, *58–60*
　A/W 2004 67
　A/W 2005 32, 74
　A/W 2006 *78–9*, 80
　A/W 2007 81, *82*
　A/W 2008 *12–13*, 85
　A/W 2010 114
　A/W 2011 *91*, 107
　A/W 2014 *108*, 114
　A/W 2015 118
　A/W 2019 *130*, 138–9, *139*, 141
　A/W 2023 *154–5*
　A/W 2024 146
　S/S 1983 *24*
　S/S 2000 48, *50–1*
　S/S 2001 49, *53*
　S/S 2002 55
　S/S 2003 56
　S/S 2004 *61*, *62–5*
　S/S 2005 *70*, *72–4*
　S/S 2006 36, *76*
　S/S 2007 81
　S/S 2008 81, *83*
　S/S 2009 *84*, 85
　S/S 2010 *88*
　S/S 2011 *94–5*, *96*, 98
　S/S 2012 *102*
　S/S 2013 *104–5*, 106, *109*
　S/S 2014 109, *110*
　S/S 2015 *112–13*, 114–18
　S/S 2016 *117*
　S/S 2017 118, *119*
　S/S 2018 *16–17*, *39*, *120*, *123*
　S/S 2019 135–8, *135–7*, 140
　S/S 2021 142
　S/S 2023 *143*, 145
Coppola, Sofia 118
coronavirus pandemic 141, 142, 145
cover-ups 49

Dada 114
Designer of the Year Award 98
Didion, Joan *115*, 118
Dior 152
Dior Homme 131
dresses
　A-line 81
　bubble-hem 138
　caped 121, 146
　day/night 10
　leopard-print 48
　metallic 138, 146
　midi dresses 67
　minidresses 56, 72, 76, 84, 98, 135
　ruffled 138
　silk-draped 121
　slip 52
　trench 95
　tulle-hemmed 48
　ultra-feminine 93

equestrian heritage 22, 49, 82
exercise equipment 38

Fashion Magazine (Canada) 30, 48
Fashionista 142, 144

feathers 85
feminism 132
Figaro, Le 135, 138
fragrances 22, 132
Friedman, Vanessa 138, 142, 146
functionalism 118

Gap 118
Gardner, Ava 75
Gen Z 142, 145
Gerber, Kaia 145
Gillot, Marie-Agnès 114
gloves 22, 81
GQ 44
Guardian, The 141
Gucci 141
Guest, C.Z. 67

Harper's Bazaar 125
hats 38
　baseball caps 144, 145
　beanies 142
　berets 81
　floppy 76, 142
Havins, Alexa *33*
Hawn, Goldie 44
headbands 72
headphones 38
Hepburn, Audrey 67
heroin chic 142
Hilton, Nicky 55
hippie style 56
Höch, Hannah 114
Holgate, Mark 72
Horyn, Cathy 89, 132
Hôtel Colbert (Paris) 135

Iggy Pop 146
Indian style 56
indie rock 'n' roll 145, 146
Internet 118

searches 125
Interpol 146
"It" brands 43, 94

jackets
 bomber 145
 cropped 48, 81, 85, 144, 146
 leather 81, 85, 138, 139, 145
 metallic fringed 146
 military/aviator 52, 56
 varsity 142
Jacobs, Marc 43, 56, 89
Japan 22
Jean, Grand Duke of Luxembourg 22
jeans, cropped 144
jewellery 56, 85, 94, 114
Jolie, Angelina 66, 135
Jovovich, Milla 54

Kardashian, Kim 98
Kennedy, Jacqueline 44, 48, 51
Kering 132
Kills, The 146
Kors, Michael 9, 10, 30, 42–67, 49, 60, 71, 72, 85, 89, 94
Kunst-Werke Institute for Contemporary Art (Berlin) 131
Kurková, Karolína 55
lace 118
Lady Gaga 135, 140, 153
Lang, Helmut 90
Lawrence, Freya 118
leather goods 21, 52, 55, 151
Loewe 43
logos
 horse and carriage 22
 red elephant 21, 22
 Slimane era 135, 144
 Triomphe (double-C) 9, 21, 22, 28–39, 62–5, 141, 151
 typed "Céline" 30
Lopez, Jennifer 48, 51, 58
Lothar's (New York) 44
Louis Vuitton 43, 55, 89, 152
Lowthorpe, Rebecca 60
LVMH 25, 43, 56, 71, 74–5, 89, 93, 125, 131, 132, 139, 141, 145, 146

McCall, Tyler 142, 144
McCartney, Stella 89, 90
Madonna 55, 90
Meghan, Duchess of Sussex 11
Menichetti, Roberto 71–5, 72, 85
Menkes, Suzy 72, 114
menswear 114, 132, 138, 142, 143, 147
Metropolitan Museum of Art (New York) 30
Michael, George 109
Miller, Lee 114
minimalism 30, 71, 74, 89, 90, 93, 95, 98, 109, 122, 125, 135, 151
Mower, Sarah 72, 74, 76, 95, 121, 138, 139, 142
Mulligan, Carey 150

necklaces, layered 85
New York Times Style Magazine, The 118
New York Times, The 72, 74–5, 114, 132, 142, 146

Observer, The 44, 48, 56
Ogunnaike, Nikki 139
Old Celine 125, 139, 141
Olsen, Mary-Kate and Ashley 98
Omazić, Ivana 30, 75–85, 75, 80

Paris Fashion Week 145
"Paris La Nuit" collection 135
Peynet, Raymond 21
Phelps, Nicole 80, 81, 94
Philo, Phoebe 9, 14, 25, 30–1, 85, 89–125, 90, 131, 132, 138, 139, 151
Philophiles 114, 125, 141
Polynesian prints 85
pom poms 118
Prada 75
Prada, Miuccia 75
Prorsum 71
punk rock style 134, 135

Quartz 141

ready-to-wear 21, 22, 48, 52, 56
Resort 2010 93
Rider, Michael 152
Rodriguez, Narciso 43, 60
ruffles 138, 142, 146

S&M-ready fashion 49–52
Sagan, Françoise 81
Saint Laurent, Yves 131, 132

sandals 98, 106
Sander, Jil 71, 90
sarongs 48
scarves 67
Seberg, Jean 67
Sevigny, Chloë 48, *49*, 145
shirts
 button-down 48
 hibiscus-printed 60
 polka dot 142
 see also blouses
shoes
 ballet flats 144
 children's 14, 21, 151, 152
 furry-soled 98, *106*
 platform Mary-Jane 146
 sandals 98, 106
shorts
 athletic 144
 knee-length 142
skirts
 A-line 77, 80, 138
 beaded 85
 flouncy 81
 flowy 80
 hibiscus-printed 60
 iridescent 81
 knee-length 81, 138
 miniskirts 67
 pencil 74, 81
 plaid 22
 voluminous 85
Slimane, Hedi 9, 10, 14, 31, 37, 38, 125, 131–47, *133*, 151, 152
social media 125, 145
sportswear 44, 47, 67, 85, 152
 couture/luxe 9, 22, 48, 52, 98
Square, Jonathan 106
Stade Louis II (Monaco) 142
Stael von Holstein, Franka 75
Stam, Jessica *76*
Strokes, The 146
suits
 blood-red 118
 chic skirt 146
 cinched waist 81
 classic skirt 80
 double-breasted skirt 67
 oversized skirt 121
 skinny tie 138
 slim 146
sunglasses 38, 146
sweaters 52, 60
swimsuits 49, 76

T Magazine 90
T-shirts 38
 oversize 109
Tahiti-style 60
Telegraph, The 95
Teller, Juergen 98
Tennant, Stella 98
tie-dye prints 56
Tik Tok 142, 144, 145
tops
 boat-necked 114
 cropped 144
 draped 94
 frayed 98
 strapless 49
 see also blouses; shirts; sweaters; T-shirts
tribal prints 85
Triomphe logo 22, *28*, 29–39, *31*, *32*, *36*, *37*, *38*, 62–5, 141, 151

trompe l'oeil details 118
trousers
 capri 72
 classic 114
 cropped 94
 cropped jeans 144
 flowy 74
 leather 146
 skinny 139
 wide-leg 52, 94
turtlenecks 22, 80

Unbearable Lightness of Being, The (Kundera) 81
unisex clothing 138, 146
United States 22
Unmade Bed, The (Sagan) 81
utilitarianism, sophisticated 94, 95

Vestiaire Collective 125
vests, tuxedo-like 81
Vipiana, Céline 9, 21, 22, 25, 29, 146, 152
Vipiana, Richard 21, 22
Vogue 48, 60, 72, 74, 76, 80, 81, 94, 109, 114, 121, 138, 139, 142

Wall Street Journal 118
Washington, DC 22
Werbowy, Daria 98, *103*
Witherspoon, Reese *93*
Women's Wear Daily 55, 56, 76, 94, 121
workwear 114, 125

CREDITS

The publishers would like to thank the following sources for their kind permission to reproduce the pictures in this book.

Alamy: Grzegorz Czapski 25, f8 archive 24; 115; Retro AdArchives 103

Getty Images: Toni Anne Barson/WireImage 12–13, 76; Pool Bassignac/Rossi/Gamma-Rapho 73; Edward Berthelot 38; Stephane Cardinale/Corbis 37, 60, 63, 64–65, 83, 107, 109, 111, 112–113, 117; Dominique Charriau/WireImage 92; Rommel Demano 15; James Devaney/WireImage 58; Michel Dufour/WireImage 72, 74, 78–79, 80; Estrop 122, 123; Fairchild Archive/Penske Media 34–35, 77, 84, 88, 96, 106, 108; Antonio de Moraes Barros Filho/WireImage 91; Swan Gallet/WWD/Penske Media 119, 136–137; Giovanni Giannoni/Penske Media 42, 45, 47; Giovanni Giannoni/WWD/Penske Media 32, 61, 62, 70, 90, 102, 116; Jesse Grant/Variety 153; Jonas Gustavsson/MCV Photo for The Washington Post 16–17; Thomas Iannaccone/WWD/Penske Media 94, 95; Jean Baptiste Lacroix/WireImage 57, 59, 93; Nathan Laine/Bloomberg 10; Michelle Leung/WireImage 82; Pascal Le Segretain 147; Stephen Lovekin/FilmMagic 33; Caroline McCredie 99; Jeremy Moeller/Getty Images 36; Max Mumby/Indigo 11; Anne-Christine Poujoulat/AFP 135; Ron Galella, Ltd./Ron Galella Collection 20; Andrey Rudakov/Bloomberg 126–127; Joel Saget/AFP 110; Saviko/Gamma-Rapho 143; Andrew Savulich/NY Daily News Archive 49; Daniel Simon/Gamma-Rapho 46; Pool Simon/Stevens/Gamma-Rapho 50, 55; Kirstin Sinclair 100–101; Robert Smith/Patrick McMullan 154–155; Jim Spellman/WireImage 66; Srreetstyleshooters 144; Andrew Toth/FilmMagic 150; Pierre Verdy/AFP 75, 97, 104–105; Victor Virgile/Gamma-Rapho 39, 51, 52, 53, 124, 140; Peter White 28, 120, 130, 133, 134, 139; Matt Winkelmeyer 8;l Yanshan Zhang 140

Mary Evans: Keystone Pictures USA/Zumapress.com 23

Vincent Peters for Céline 54

Courtesy of Satoko Mukai 31